THE ICON

Holy Images — Sixth to Fourteenth Century

THE ICON

Holy Images—Sixth to Fourteenth Century

KURT WEITZMANN

GEORGE BRAZILLER NEW YORK

Published in 1978.

For information address the publisher:
George Braziller, Inc., One Park Avenue, New York, New York 10016

Library of Congress Cataloging in Publication Data

Weitzmann, Kurt, 1904–
 The icon.

 Bibliography
 1. Icons. 2. Icon painting. 3. Votive
offerings in art. 4. Christian art and symbolism.

I. Title.

N8187.W44 704.948'2 78-6495

ISBN 0-8076-0892-0

ISBN 0-8076-0893-9 pbk.

First Printing

Printed by Imprimeries Réunies in Switzerland.

DESIGNED BY RANDALL DE LEEUW

CONTENTS

6

ACKNOWLEDGMENTS

The author and publishers would like to express their sincere thanks to the following institutions and individuals who kindly provided materials and granted permission to reproduce them in this volume.

Color Plates

ATHENS, Benaki Museum, Plate 46.

ATHENS, Byzantine Museum, Plate 35.

BERLIN, Staatliche Museen, Preussischer Kulturbesitz, Plates 3, 11, 15.

CLEVELAND, The Cleveland Museum of Art, Plate 4, Purchase, Leonard C. Hanna Jr. Bequest.

FIESOLE, Museo Bardini, Plate 13 (Photo: Dott. G.B. Pineider).

ISTANBUL, Istanbul Archaeological Museum, Plate 10 (Photo: Erkin Emiroglu).

KIEV, City Museum of Eastern and Western Art, Plate 7 (Photo: Kurt Weitzmann).

LONDON, Victoria and Albert Museum, Crown Copyright, Plate 45.

MOSCOW, The Pushkin Museum of Fine Arts, Plate 42, Copyright, Isobrazitelnoe Iskusstvo.

MOSCOW, Tretyakov Gallery, Plate 21, Copyright, Isobrazitelnoe Iskusstvo.

MUNICH, Schatzkammer München, Plate 16 (Photo: Bernhard Mayer).

OHRID, The National Museum, Plate 44 (Photo: Charles Passela).

PARIS, The Louvre, Plate 28 (Photo: Cliche Musées Nationaux Paris).

ROME, Benedettine di Priscilla, Plate 5.

ROME, S. Maria in Trastevere, Plate 6 (Photo: SCALA, Florence; Courtesy of the Istituto del Restauro).

SINAI, Saint Catherine's Monastery, Plates 1, 2, 8, 9, 17, 18, 19, 20, 22, 23, 24, 25, 26, 27, 29, 30, 31, 32, 33, 34, 36, 37, 38, 39, 40, 43, 48 (Published by permission of the Alexandria-Michigan-Princeton Expedition to Mount Sinai).

SOFIA, Copyright Agency, National Gallery, Sofia Plashtad Slaveykov, Plate 47.

UTRECHT, Rijksmuseum Het Catharijneconvent, Plate 12.

VENICE, San Marco, Plate 14 (Photo: Charles Passela).

WASHINGTON, Courtesy of the Dumbarton Oaks Collection, Plate 41.

Black-and-White Figures

BERLIN, Staatliche Museen, Bildarchiv Preussischer Kulturbesitz, Figure IV.

LONDON, Victoria and Albert Museum, Figures B, E.

MALIBU, J. Paul Getty Museum, Figure V.

MOSCOW, Historical Museum, Figure I (Photo: Kurt Weitzmann).

NOVGOROD, United Novgorod State Museum-Preserve, Figure F[1] (Photo: N.S. Karmazin), Figure F[2] (Photo: A.I. Komyoch).

PARIS, The Louvre, Figure III.

PARIS, Figure D (Photo: Giraudon).

SINAI, Figures II, VI, VII (Published by permission of the Alexandria-Michigan-Princeton Expedition to Mount Sinai).

VENICE, S. Maria Mater Domini, Figure A (Photo: Hans Belting).

VENICE, San Marco, Figure C (Photo: Bildarchiv Foto Marburg).

INTRODUCTION

The word "icon" in the broadest sense means simply "image," any image, but in the more restricted sense in which it is generally understood, it means a holy image to which special veneration is given. The icon plays a very specific role in the Orthodox Church, where its worship in the course of time became integrated into the celebration of the liturgy. In the Latin West, where Eastern icons were copied with varying degrees of faithfulness, some images enjoyed special veneration, particularly those supposedly endowed with miraculous powers. Yet, on the whole, holy images in the Latin West did not attain the same exalted position which they occupied in the life of the Orthodox believer. According to the Greek Church Fathers, such as Basil, the icon was considered equal in importance to the written word, the appeal to the eyes being just as authoritative as that to the ears.

However, as the icon ascended to a central position in the Eastern Church it encountered wide opposition. Traditional forces considered the worship of icons to be idolatry, which they thought they had overcome in their fight against paganism. Moreover, a widespread aversion to the representation of the human form was rooted in the Jewish heritage of early Christianity as expressed in the Fourth Commandment, "Thou shalt not make unto thee any graven image . . ." (Exodus 20:4). In the fourth century the zealous Bishop Epiphanios of Salamis had in anger torn down a holy image painted on a curtain. Yet the desire to depict divine and saintly figures in human form spread throughout the Church of the Gentiles after Hellenic culture, in all its manifestations, had been adapted to Christian thought and life.

There resulted a clash between the icon worshippers (iconodules) and the icon destroyers (iconoclasts) of such violence that it led to a civil war (726–843) which shook the foundations of the Byzantine Empire. This situation forced the icon worshippers to define with precision the difference between a pagan idol and a Christian icon. Neither the materials, usually wood and colors, nor the images themselves were being wor-

shipped, they argued, but the prototype behind the image which became manifest through the representation. Moreover, John of Damascus (eighth century) in his *Defense of Holy Images* agreed with his adversaries that God, being invisible, inconceivable, and limitless, could not be represented, but argued that because God had, through Christ, become man, Christ could and must be depicted in human form for the sake of man's salvation. Thus, the defense of the images was based largely upon the doctrine of the Incarnation. When the Empress Irene reintroduced the worship of icons, the event was of such importance that it is still celebrated today on the first Sunday of Lent in the Orthodox Church, and it led to an extraordinary proliferation of icons of Christ, the Virgin, the great feasts, the saints, and events of their lives.

There exist miniatures depicting the destruction as well as the worship of icons. In a ninth-century Psalter in Moscow (Figure I) an irate iconoclast, using a sponge, effaces a round icon of Christ. Another miniature, in an eleventh- to twelfth-century manuscript of the *Heavenly Ladder* by Saint John Climacus, Abbot of Sinai, illustrates the worship of the icon by monks, who are either bowing, kneeling, or prostrating themselves in what is known as *proskynesis* (Figure II).

Painted cult images were, however, not a Christian invention, since they had various roots in Late Antiquity. Best known are the mummy portraits of Egypt, which, as is true of so much of that country's art connected with funerary cults, have survived in great quantity in the desert sand. Painted for the most part with colored wax in the encaustic technique, they extend from the first to the fourth century A.D., and it is in such later examples as the female portrait in the Louvre (Figure III), with its tendency to abstract design and the large expressive eyes that seem to gaze into the other world, that a relationship to early icons (see the medallions in Plate 8) can best be perceived.

Yet the influence of mummy portraits, although most conspicuous today, may not have been the most decisive element when icon painters sought inspiration. Except for funerary art, so few panel paintings have survived that it is merely accidental that one with an imperial portrait, now in Berlin (Figure IV), has come down to us. It depicts the Emperor Septimius Severus (193–211) with the Empress Julia Domna and their sons Caracalla and Geta (the latter's face purposely obliterated after his brother murdered him). Not encaustic, but painted in a technique resembling tempera, it is, significantly, in the shape of a roundel—a *clipeus*—a symbolic form which was used in Late Antiquity to render the transport of the soul to heaven. Such panels played a role in the Emperor Cult, and it is known that imperial portraits were carried in processions.

I

II

But while the pagans had preferred sculpture in the round for the worship of deities, there also existed painted panels of gods and goddesses, and these seem to have been particularly popular among the mystery religions. Several encaustic panels have survived from the cult of Isis. The J. Paul Getty Museum in Malibu, California, possesses two wings of a triptych with busts of Sarapis and Isis (Figure V), whose hieratic quality, enhanced by their wide open eyes and aloof gaze, is akin to that seen in the early icons of Christ and the Virgin (Plates 1–6).

Just as varied as the icons' ideological roots are their shapes. The most common is the single, rectangular panel which has a long history in classical art and has remained the most persistent shape throughout the history of icon painting. But in addition, the *tondo* or roundel must have played a considerable role, as is clearly reflected in the Psalter miniatures of the ninth century (Figure I). In ancient times this shape was used not only for imperial portraits (Figure IV), but for portraits in general, as suggested by some Pompeian frescoes. When Christians employed this shape they may, at least at the beginning, have still been aware of the

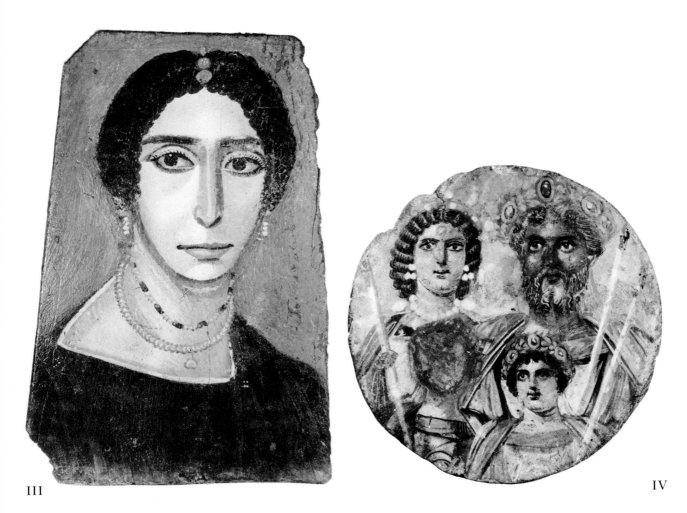

III

IV

significance of the *clipeus* as associated with the lifting of the soul to heaven. The roundel never entirely died out in icon painting: a serpentine with a bust of the Orant Virgin (Figure B) and a lapis lazuli disk with the Crucifixion in gold (Figure C) are prominent works of the Middle Byzantine period, from which a painted fragment from the eleventh to twelfth century also survives at Mount Sinai; even as late as the seventeenth century there are several known *tondi* with the busts of Saint Paul and Saint Peter embracing.

The folding diptych had its roots in ancient writing tablets. It was usually made of wood, but during the fifth and sixth centuries the more precious ivory was used, particularly for consular diptychs. It was from the consular diptychs that the Christians adapted this form for religious purposes (Plate 3), and often wrote liturgical prayers on it at a later stage. In the tenth century the ivory diptych was quite familiar, while from the eleventh century onward we have quite a number of wooden diptychs, of

which one with the Virgin and Saint Procopius from the thirteenth century (Plate 37) is a typical example.

Much more popular, however, was the triptych, because it was a particularly suitable form for holy images. Covering the central panel with the wings and opening the triptych only for private worship created a dramatic effect. Triptychs were already common in antiquity, as copies in Pompeian frescoes testify, and we have already mentioned triptych wings depicting Isis and Sarapis (Figure V). It is therefore hardly surprising that among the early icons at Mount Sinai there are a considerable number of parts of triptychs, most of them of small size (Plate 9). Triptychs were easily transportable, their central panels being properly protected.

During the Middle Byzantine period (853–1204) even more complex forms developed. A Last Judgment icon (Plate 23) is part of a quadriptych, in which two outer wings were hinged to the two inner ones, and the whole folded like a diptych. Apparently exceptional is the hexaptych whose inner four wings contain a complete calendar of the year (Plate 17), flanked by wings with a New Testament cycle and a Last Judgment.

Literary sources make it quite clear that the earliest icons were made largely for private ownership in response to popular demand. Accordingly, the Church reversed its initially cautious and at times hostile attitude, and the church building itself was turned into a veritable treasure house of icons, which were displayed in a number of ways. As could be seen until very recently in the church of Saint Catherine's Monastery on Mount Sinai (Figure VI), icons were hung in a long row along the north and south walls of the basilica in the sequence of the calendar. On the day of a special feast or the commemoration of a particular saint, the appropriate icon was taken from its hook and displayed on the *proskynetarion,* a baldachin-covered lectern to be seen at the left in the nave. Here the priest would bow in what is called the *proskynesis* and kiss the icon. Since it was hardly possible to have an individual icon for every saint of the year, the so-called calendar icon came into being—the earliest known examples date back to the eleventh century (Plate 17)—with the saints for the whole year distributed over a number of panels, most conveniently twelve corresponding to the months. In the Sinai church such a set of huge icons hangs on the twelve columns supporting the nave, the one that includes the saint of the day being illuminated during the service. In addition, large individual icons were placed higher up on the walls (for example, Plates 18, 29), and some, with special saints, in the chapels dedicated to them (Plates 33, 34).

In the course of time the so-called *templon,* or iconostasis, which separates the nave from the sanctuary, became the focal point of icon worship. Originally, when executed in marble or on occasion in silver, as in

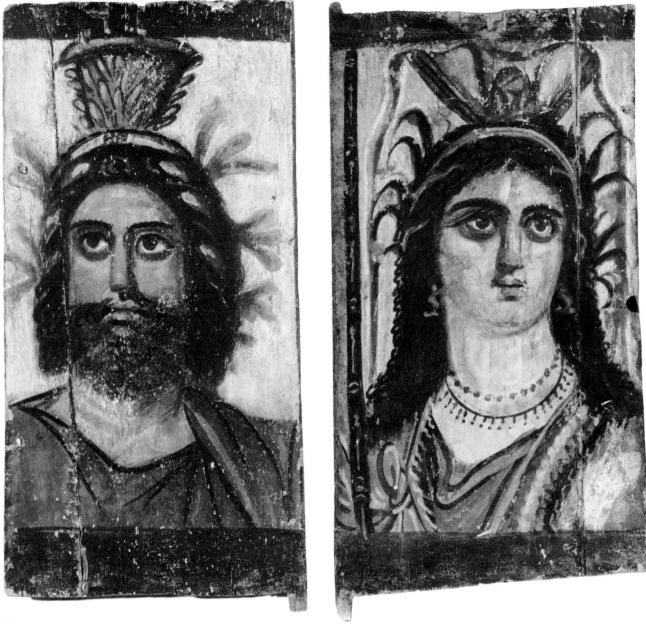

V

Saint Sofia in Constantinople, only the architrave had figurative medallions, while the spaces between the upright pillars were closed by curtains. In about the tenth century there were placed atop the architrave painted wooden beams with representations of the twelve major feasts of the Orthodox Church, the so-called *dodecaorton*, interrupted in the center by the *Deësis* showing Christ flanked by the Virgin and Saint John the Baptist

as intercessors (Figure VII) and sometimes by the archangels and Apostles as well. By roughly the eleventh century the intercolumnar spaces were filled, normally with four icons, two on either side of the entry into the sanctuary. Once more the main theme was the *Deësis*, consisting of life-size and sometimes larger than life-size busts of Christ, the Virgin, and Saint John the Baptist. The fourth icon very often depicted Saint Nicholas (Plate 33), but in the basilica at Sinai it is Saint Catherine. At about the same time or a little later, the Royal Doors which, when opened, give a free view of the altar, were figuratively decorated, usually with the Annunciation but occasionally with the evangelists or Moses and Aaron. During the liturgy the priest burned incense and read the Prayer of Intercession before the icons of the iconostasis.

A special type are the bilateral icons, some of which were obviously carried in processions (Plates 35, 47), whereas others, too heavy to be lifted (Plate 38), were perhaps set into an iconostasis to be seen by the community as well as by the celebrating priest, or elsewhere where they could be viewed from both sides.

One usually associates an icon with a painted panel. However, it must be realized that the enormous preponderance of icons existing today do not date back beyond the thirteenth century, those of earlier periods being extremely rare. From the fourteenth century onward, during the so-called Palaeologan period (1261–1453) named after the last dynasty of Byzantine emperors, and increasingly after the Fall of Constantinople in 1453, the painted panel was indeed the predominant medium. But this had not been the case to such an extent during the preceding centuries, and it is essential to realize that the icon as a religious object is not bound to one particular medium. There were centuries in which other media were equally popular.

If, nevertheless, most of the earliest extant icons are painted, this may well be accidental, since many other media, which will be discussed below, were more susceptible to destruction. Most of the surviving examples of the early period were executed with heated wax in the traditional encaustic technique (Plates 1–2; 6–8), known chiefly from mummy portraits (Figure III). In spite of the fact that most surviving encaustic panels were found in Egypt, the technique was also widespread in other Mediterranean countries, and there is no compelling reason to consider every early Christian encaustic icon, such as those at Sinai (Plates 1, 2, 8), to have been derived from Egyptian inspirations. Moreover, as old as the encaustic technique for icons was the use of tempera, which also existed in Late Antiquity—the imperial *tondo* (Figure IV) and the Sarapis-Isis panels (Figure V) being eloquent witnesses to this.

Almost as soon as icons were collected in the churches, they were copied on the walls in fresco technique as proved by the fresco panel with the Virgin and Saints in the funerary chapel of the Commodilla Catacomb in Rome (Plate 5), a panel which retains its integrity as a self-contained, hieratic sacred image. How popular such fresco icons were, isolated in certain places on the vast expanse of a church wall, can still be inferred in such widely separated localities as Santa Maria Antiqua in Rome and the Cathedral of Faras in Nubia. In some later churches in Yugoslavia, icons were imitated in fresco, complete with frames and hooks.

The mosaic, a medium used in antiquity primarily, although not exclusively, for floor decoration, was elevated to a higher status in the Christian Church and used primarily for apse, but also for wall decoration. Soon icons as well were executed in this technique and placed on church walls in various spots where they could serve devotional purposes. The best examples from the Early Byzantine period are preserved in the Church of Hagios Demetrios in Thessalonike, depicting that saint with various donors. But from the Middle Byzantine period onward, mosaic was also used for smaller, portable icons. The size of the tesserae decreased in an attempt to achieve a more painterly effect (Plates 28, 32), at the same time relinquishing the earlier, stylizing power derived from the clearly recognizable larger cubes. In the Late Byzantine period, in an attempt to imitate fleeting brush strokes, the tesserae became so tiny that they can hardly be recognized as such by the naked eye (Plates 41, 45). Preciousness and durability were apparently the motivations of the artist, although the latter did not always keep its promise.

The story of Epiphanios of Salamis tearing down a holy curtain with a holy image depicted on it suggests that at an early time there also existed textile icons. This was confirmed a few years ago when there came to light a huge woven hanging from the Early Christian period, now in the Cleveland Museum (Plate 4), representing the enthroned Virgin with Child in the same stately, hieratic pose as the comparable encaustic painting at Sinai (Plate 2). There are also preserved, especially from the post-Byzantine period, embroidered icons, one of which, with Saint Catherine enthroned, is displayed before her tomb in the presbytery of Saint Catherine's Church —that is, in the most conspicuous spot at the holy site.

After a slackening of artistic activities during the iconoclastic period, a second golden age dawned under the emperors of the Macedonian dynasty (867–1056), which is rightly called the Macedonian Renaissance. Its primary contribution to the production of icons was a more lavish use of all the different precious materials that had given distinction to the production of fifth- and sixth-century art, especially that of the Justinianic

age. But while used then for both pagan and Christian subjects, now precious materials were more exclusively pressed into the service of religious art. Some believers of the time may well have wondered whether such a display of luxury was not in conflict with the basic purpose of a devotional image. That there remain so very few painted icons from this period may be due less to large-scale destruction than to the fact that icon production was, to a larger extent than we today realize, entrusted not to painters, but to carvers of marble, stone, and ivory, as well as to workers in metal and enamel.

The Macedonian Renaissance asserted itself in a renewed use of marble, though not sculpted in the round (which still bore the stigma of idolatry), but in relief, which, though relatively flat, often suggests considerable three-dimensionality. The production of marble sculpture as such had been reduced to a trickle between the seventh and ninth centuries, and was mostly incised or executed in the technique of colorful marble intarsia as exemplified by the Eudocia icon in the Museum at Istanbul (Plate 10), which stresses the dematerialized human body. From the tenth to the twelfth centuries a considerable number of marble icons have come down to us. Most of these are of a stately size, surely made for display in churches (Figure A). For personal use, in the wake of a revival of gem carving, more precious stones were sometimes used for icons, such as the deep green serpentine used for the Virgin Orant roundel in the Victoria and Albert Museum, the best known piece of its kind (Figure B).

But by far the most preferred medium for small portable icons was ivory, which, after a superb flowering in the fifth and sixth centuries (Plate 3), saw its greatest revival during the tenth century when several ateliers worked in Constantinople side by side. One concentrated on transforming painted models into carving, producing the so-called "painterly group" of icons, and at the same time using classical models for its figure types, as can easily be detected among the nudes of the Forty Martyrs of the Sebaste panel in Berlin (Plate 11). Another atelier, working for the imperial court, produced the so-called Romanos group, combining extreme elegance with strong hieratic quality, as exemplified by the aristocratic Virgin at Utrecht (Plate 12). Competing with ivory, and, when the latter became less easily available, overtaking it, was steatite, whose smooth, creamy surface resembles ivory. The preciousness of the marble, ivory, and steatite was enhanced by the sparing use of gold for borders or for patterns on a garment, as can still be seen in a steatite of the Archangel Gabriel at Fiesole (Plate 13). This refinement has its roots in classical art, where chryselephantine works were produced for the most venerated images, such as the Zeus by Phidias. To visualize the full splendor of the ivory icons, it must be realized that

those that were single plaques (Plate 11 for example) were originally mounted on a wooden core and framed. Unfortunately the ivory with the Nativity in Paris (Figure D) is the only one which has come down to us with its original, though badly battered, silver frame.

It is indicative of the difference between East and West that wood carving, so widely employed in sculpture in the Latin West, is found very sparingly in Byzantine art, and where it was used for an icon, such as that of Saint George in Athens (Plate 35), the work was closely related iconographically and stylistically to Western art.

One will never know the extent of the use of various metals for icons because of their destructability. A rare survival in solid gold is the precious Crucifixion group, mounted on a lapis lazuli disk, in the treasure of San Marco in Venice (Figure C). Once more it was the art of Late Antiquity that provided the inspiration for such exquisite taste. Equally high artistic quality could be achieved in gilded bronze, as demonstrated by the triptych in London with the Virgin enthroned, flanked by the Church Fathers Gregory of Nazianzus and John Chrysostom (Figure E). Yet in form and style this triptych is more closely allied to ivories (Plate 12) than to solid gold works, which most likely existed only to a limited extent in such a relatively large size.

Another metal technique is that of combining painting with embossed silver or gilded silver, and in rare cases gold, as in the Saint Michael icon in Venice, where the archangel's face and hands are worked in subtle relief (Plate 14). But even at the time of its creation this must have been a great rarity; usually the combination of metal and painting was reversed, and the painted heads and hands showed through, while the rest of the painted icon was covered by a silver sheet. Since this technique, however, is comparatively rare in Greek icons, but much more widespread in Georgian as well as Slavic, especially Russian icons—the icon with Saint Peter and Saint Paul in Novgorod is a striking example (Figure F)—the Russian terms *oklad* or *riza* are most commonly used for this kind of concealment. Where the metal covers only the frame or the frame plus the adjacent background, leaving the whole painted figure free, the term *basma* is used (Figure D).

In one technique the Byzantines even surpassed antiquity. In the period from roughly the tenth to the twelfth century Constantinople developed *cloisonné* enamel to a refinement never achieved before and never surpassed after. The delicate design formed by a network of gold lines, soldered on gold ground, and the cells they form filled with partly translucent colors, especially a deep sea green, create an ethereal effect of rare beauty, particularly suitable to an icon emanating spiritual power. Moreover, the dematerialized human figures created in this way—be they

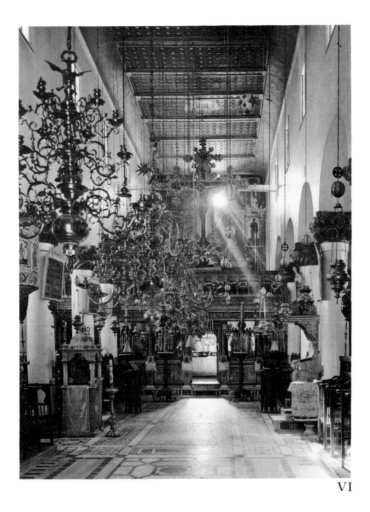

VI

individual saints (Plate 15) or part of a feast scene (Plate 16)—show a highly decorative and balanced color distribution which results in a comparatively higher degree of abstraction than is common in other media of this period. Frequently *cloisonné* enamel was used in combination with embossed gold relief, as in the Saint Michael icon already mentioned (Plate 14).

A history of the icon from the sixth through the ninth centuries according to style and content cannot yet be written because of the extreme scarcity of the material, which has been preserved almost exclusively at Mount Sinai, where it escaped the destruction of the iconoclasts. Even where the tenth century is concerned, the history of the painted icon is still an enigma, since only a handful of examples have come to light, once more at Mount Sinai, although a substantial number are preserved in other media, such as ivory (Plates 11, 12). A coherent picture of icon painting begins to emerge only with the eleventh and twelfth centuries. But from this period as well, the majority of extant icons are in the possession of

Saint Catherine's Monastery, and this easily explains why our study relies heavily on this unique collection. Only from the thirteenth century onward are a very considerable number of icons known from various parts of the Orthodox world—Greece, other Balkan countries, Russia, and the Near East. And it was only after the fall of Constantinople in 1453, when Crete had become the main center of Greek icon painting, that artists' signatures became common, permitting a definition of personal styles and workshop traditions, although there are exceptions from earlier centuries (Plate 29). Since so much of this late material has been published, we purposely have concentrated on the lesser-known formative centuries during which the general artistic level seems to have been higher than in the later centuries when mass production prevailed.

At Sinai there have been discovered three great masterpieces from the sixth and early seventh century (Plates 1, 2, and 8), which have revolutionized our thinking about early icon painting. Unlike mosaics of the period, such as those of Sinai and Ravenna, a free brush stroke technique, continuing an uninterrupted classical tradition, reveals the survival of a painterly style otherwise known only in certain miniature paintings. We assume that these icons, representing Christ, the Virgin, and Saint Peter, were produced in Constantinople where the classical tradition had continued with greater purity of style than in any other Mediterranean center.

Also of fairly recent date is the discovery in Rome, underneath later overpainting, of several encaustic panels from the seventh to eighth centuries, a period when several popes were Greek, and the Eastern influence was particularly strong. Yet, as seen in the Virgin icon of Santa Maria in Trastevere (Plate 6, also Plate 5), these Roman panels have in their style a distinct local flavor, and are more linear than painterly.

The only other place that, to our present knowledge, came into focus during this early period is Palestine, to which we should like to ascribe a group of Sinai icons, represented here by a panel with the "Rider Saints" Theodore and George (Plate 9) in which the classical forms have begun to erode. The Sinai Monastery, located in what was formerly Palestina Tertia, depended primarily upon Jerusalem for its ecclesiastical ties. This Palestinian atelier apparently continued to produce icons throughout the period of Iconoclasm, when the Christians of Syria and Palestine, then under Muslim rule, with the support of the writings of John of Damascus, were in a position to challenge the imperial iconoclastic decrees.

Sinai alone has a few painted icons of the tenth century as well, but they do not show the artistic level one would expect from the best Constantinopolitan art of this period. Although they do reflect a revived influence of the style of the Capital, most of them seem to have been produced at

Sinai. For Constantinopolitan icons, and this applies to those from the eleventh and twelfth centuries as well, one must, as stated earlier, turn to products in other, primarily more precious materials (Figures B–F, and Plates 11–16).

When artistic production flourished again after the end of Iconoclasm, liturgical aspects began to dominate Byzantine art in all its manifestations. A clear expression of this trend was the creation of the pictorial cycle of the twelve great feasts of the Orthodox Church, the so-called *dodecaorton*. The cycle was most ostentatiously displayed on the iconostasis beam (Figure VII), but was frequently used as the theme for small single panels, diptychs, or triptychs for private worship as well as large panels for display in the church. At first a few feasts were still interchangeable, but what one might call the canonical set consists of the following twelve feasts: the Annunciation (Plates 27, 44, 45), Nativity (Figure D), Presentation in the Temple, Baptism, Transfiguration or *Metamorphosis* (Plates 24, 28), Raising of Lazarus (Plates 19, 31), Entry into Jerusalem, Crucifixion (Figure C, Plates 16, 26, 38), Harrowing of Hell or *Anastasis*, Ascension, Pentecost, and the Death of the Virgin or *Koimesis* (Plate 40). Raised above the level of a mere narration of the Gospel story, almost every one of the feast pictures succeeds in conveying the central idea of the dogma of the Two Natures of Christ, formulated at the ecumenical Council of Chalcedon in 451, whose main tenet is the preservation of Christ's human nature after his death.

In the course of the eleventh century, the classicizing mode of the Macedonian Renaissance (Plate 11) gradually gave way to a style which exhibited a preference for a smaller figure scale and a more dematerialized rendering of the human body. Concurrently, painting assumed a dominant role, as it was more fitting for the expression of an ascetic ideal. Monasticism in general and the mysticism of monks such as Symeon the New Theologian were the main forces behind these stylistic changes. The delicate painting with its often minute and dematerialized figures—of which the calendar icons (Plate 17), the representations of the Heavenly Ladder of John Climacus (Plate 25), and the Miracle of Saint Michael in Chone (Plate 22), are characteristic — very closely resembles miniature paintings. In these as well as many similar instances a good case can be made for the argument that, indeed, icon and miniatures were produced in the same workshop by the same hand.

One of the most powerful subjects, appearing first in the eleventh century in icons as well as in frescoes, mosaics, and miniatures, is the Last Judgment, with its strong moralizing tones (Plate 23). Moreover, after the Lives of the Saints were, at the end of the tenth century, compiled by

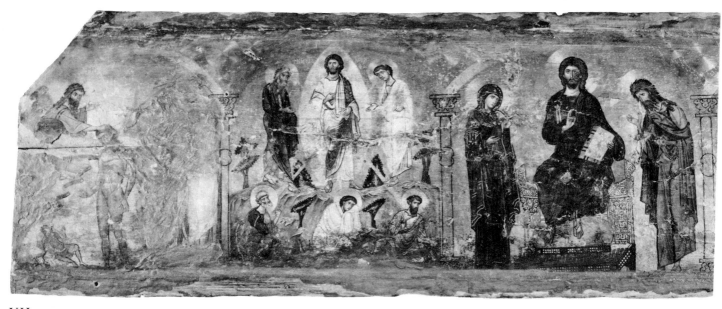

VII

Symeon Metaphrastes in the *Menologion* covering every day of the year, corresponding calendar icons came into being (Plate 17), supplementing those of individual saints which had existed from the very start of icon painting. Beginning in the twelfth century, some icons of popular saints such as Saint Nicholas and Saint George display a cycle of scenes from their lives painted all around the frame, copied primarily though not exclusively from miniatures of *Metaphrastian Lives* (Plates 33, 34, 35).

In the course of the twelfth century, at the time of the Comnenians (1081–1185), some degree of solidity was regained in the rendering of the human body, yet the effect was no longer a close imitation of classical models as it had been in the tenth century. More stylized and hieratic forms began to prevail, however, expressing a high degree of spirituality as in the icon of Saint Michael at Chone (Plate 22) or the *Metamorphosis* of an iconostasis beam (Plate 24). This high degree of spirituality which the twelfth century was capable of capturing is most persuasively rendered in the icon with the Virgin of Vladimir (Plate 21). After the middle of the twelfth century, there emerged an element of emotionalism which Byzantine art had previously avoided. Noticeable in a Crucifixion icon (Plate 26), it reached full intensity in an Annunciation (Plate 27) where the stately, matronly Virgin has been replaced by a slender woman nervously reacting to the appearance of the angel, who also seems apprehensive.

In these centuries following Iconoclasm, Constantinople had become the uncontested arbiter in all matters of culture and art, even beyond the

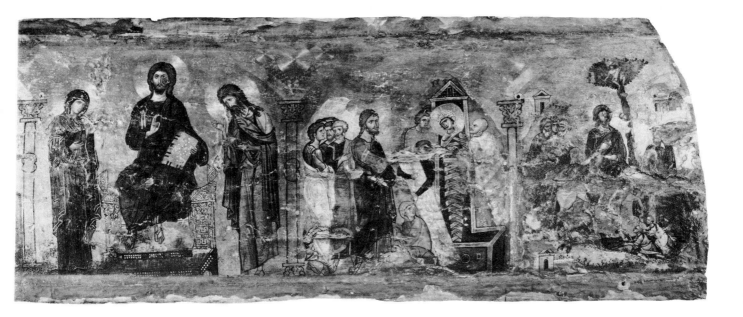

borders of the Byzantine Empire, and had created a unifying style which did not entirely eliminate, but nonetheless restricted, local styles wherever they survived. It is thus much more difficult in Byzantium than in the Latin West to distinguish local styles during this period. One local center which, despite a strong dependence on the Capital, reveals some character of its own is Cyprus (Plates 19, 20). Here the human figures show a relatively higher degree of abstraction, and the architectural features are more ornamentalized than in works attributed to Constantinople. To learn to distinguish other centers will be the task of future research.

The thirteenth century was one of the liveliest and most revolutionary centuries in Byzantine art and we are still far from comprehending all of its trends, their interrelations, and their sources. The emotional element continued to assert itself, but now it was no longer achieved by linear means as in the Annunciation icon (Plate 27), but rather by a rich coloration which was no longer based upon enamel-like, primary colors (Plate 24), but upon a rich shading and illuminating striking for their painterly effects. The Raising of Lazarus as depicted on an iconostasis beam (Plate 31) with its unusual, deep-glowing mystical colors, is a characteristic witness to this new trend. In the hands of the great master who signed the Elijah icon (Plate 29), the combination of painterly and emotional qualities with monumentality and remoteness resulted in the creation of an icon of rare individuality. A similar fusion of passionate feeling and hieratic form can be sensed in such icons as the *Metamorphosis* in the Louvre, executed in

mosaic (Plate 28). But contemporary with them were other ateliers which continued to prefer the more linear style to stress more explicitly hieratic monumentality, as may be seen in the mosaic icon of the *Hodegetria* (Plate 32) and the icons of Saint Nicholas and Saint George (Plates 33, 34).

Moreover, thirteenth-century icon art has yet another dimension, momentous and unforeseen, resulting from the occupation of Palestine by the Crusaders and the conquest of Constantinople in 1204 by the Venetians. A lively artistic interaction began at the very moment when the Latin West, in the age of the cathedral, met the East as an equal. Primarily in Jerusalem, until its fall in 1244, and then in Acre, until its fall in 1291, a considerable number of artists from many different nations settled in the Holy Land and produced what one might call "Crusader art," icon examples of which have become known only very recently with their discovery at Sinai. Most of the Latin painters were obviously Italian (Plates 37–40), some most likely Tuscans, and others almost certainly Venetians. While they often copied the subject matter of Greek models very closely, as in the case of the Death of the Virgin (Plate 40), at times their native temper asserted itself in a greater realism, as in the case of a Crucifixion with a Herculean Christ figure (Plate 38). We believe the soulful Moses (Plate 36) to have been executed in a French atelier which was likewise very active. Individual icons have been ascribed to migrating artists from England and Germany. What distinguishes these Crusader icons from the Byzantinizing art of Italÿ proper, the so-called *maniera graeca,* is the greater empathy with which they tried to capture the spirit of the Greek models. There are cases in which we are yet unable to distinguish clearly between Byzantine original and Latin copy.

When reconstruction of the Byzantine empire began in 1261 under the Palaeologan dynasty, although with shrunken boundaries, there occurred a revival of older Byzantine traditions for which the term "Palaeologan Renaissance" has been introduced. This was a reaction, at least in part, against the Latin influences of the immediate past, characterized by a seeking of new inspiration in various phases of the Byzantine past, notably the classicizing style of the tenth-century Renaissance. When the mosaic icon of the Forty Martyrs (Plate 41) is compared with the tenth-century ivory of the same subject (Plate 11), it becomes clear not only that the corporeality of the human figure has been recaptured, but also that the spiritualizing qualities of the eleventh century have not been lost; the Palaeologan copy has fused the classical with the spiritual. Draped figures such as the twelve Apostles in the Moscow icon (Plate 42) convey the impression of voluminosity, but at the same time the slender, elongated bodies do not fill out the inflated garments.

The great masterpieces of the Palaeologan Renaissance are the mosaics and frescoes of the Kariye Djami in Istanbul (the gift of the great humanist Theodore Metochites [d. 1335]), with bodies at times so over-elongated and actions so distorted that an element of mannerism creeps in, removing the figures further from reality than in any previous period. In icon painting, this style often gives the impression of frailty and extreme asceticism (Plate 43). In a scenic composition like the Annunciation—while as was usual in this late period maintaining what one may call a canonical tradition—the artist strove to create the effect of apprehension (Plate 44) or even nervousness and fear, shared by the Virgin and angel alike (Plate 45). In the Hospitality of Abraham (Plate 46), a more lyrical mood, stillness, and a feeling of timelessness prevail.

Toward the end of the fourteenth century, the loose brush technique, which had been the chief means of achieving dematerialization and spiritualization, reached a point where the strokes formed a pattern quite dissociated from the body hidden by the garment. This almost phantom-like quality (Plate 48) attained its most expressive power in the art of Theophanes the Greek, a fresco and icon painter who had gone from Byzantium to Russia to decorate churches in Novgorod and elsewhere.

The late flowering of Palaeologan icon painting, despite the impending collapse of the Byzantine Empire, retained sufficient vitality not only to create a distinct style, but to determine the course of painting in other Orthodox, chiefly Slavic countries, and to survive even the fall of Constantinople in 1453. For another two or three centuries, post-Byzantine painting produced its best works in the many workshops of Crete, maintaining a high level of artistic accomplishment until it surrendered to the influence of Western Renaissance and Baroque art.

FIGURE A

VENICE, MARBLE ICON WITH VIRGIN ORANT

Among the numerous marble icons of the Virgin preserved in Venice, the one in the Church of Santa Maria Mater Domini belongs among the few which can be considered Constantinopolitan imports. The Virgin Orant is associated with her representation in the Church of the Blachernae in Constantinople and is thus known as the *Blachernitissa,* but the variant which shows the Virgin with the Child in a *clipeus* goes by the name *Platytera* (an allusion to her womb). The sparse use of gold for the seams of the garments and nimbi is found similarly in Byzantine ivories, as in general the handling of the Virgin's refined drapery shows distinct resemblances to the ivories by which these marble icons were apparently influenced (Plate 12). The holes in the hands may be copied from a model which served as a fountain. This Virgin type seems not to have been invented before the eleventh century, and this marble icon, which shows her standing under a delicately ornamented arch, may be one of the earliest examples still belonging to that century.

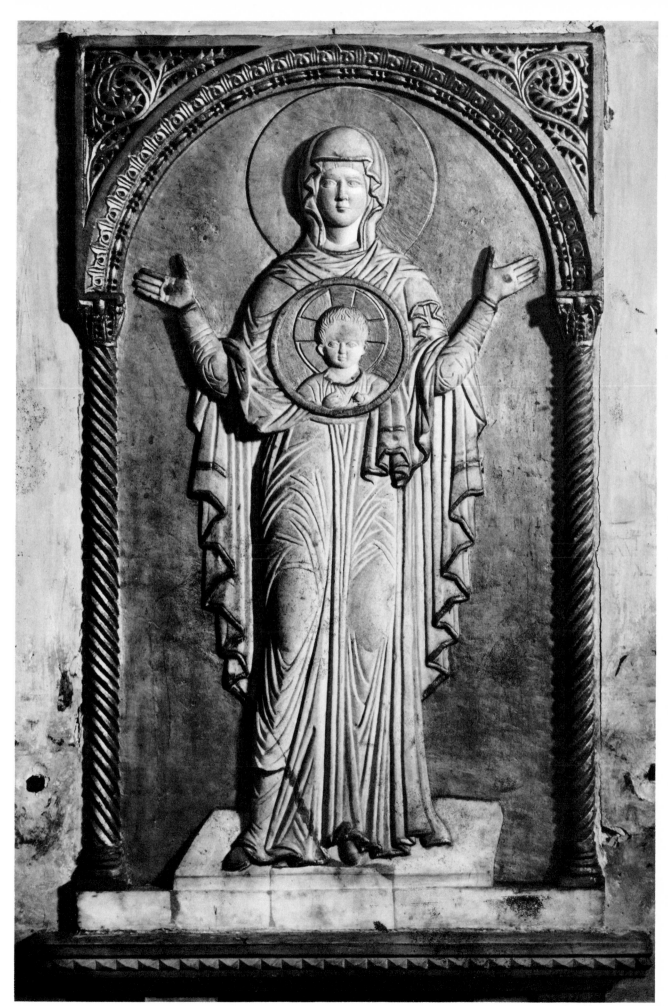

A

FIGURE B

London, Serpentine Medallion with Bust of Virgin

In the venerated form of a *clipeus* (Figure I), a bust of the Orant Virgin is carved in spotted dark green serpentine, demonstrating that in a period when preciousness of materials was highly appreciated, even gem carving was adapted to icon production. Just as was true of the marble icon (Figure A), highly developed and widespread ivory carvings also served as models for this medallion. The bordering inscription invokes the aid of the *Theotokos,* the Mother of God, for the Emperor Nicephoros III Botaneiates (1078–1081), making this one of the few firmly dated works of art of its kind.

FIGURE C

Venice, Golden Crucifixion on Lapis Lazuli

A unique piece from the Middle Byzantine period, now in San Marco in Venice, is this disc of lapis lazuli on which are mounted a solid gold Christ on a Cross and figures of the Virgin and Saint John the Evangelist. The combination of these two materials was known in Late Antiquity, one of the most striking examples being a necklace with a golden figure of Aphrodite set against a lapis lazuli seashell, now in the Dumbarton Oaks Collection in Washington. The reappearance of this technique is just one more aspect of the revival of the Late Antique love of luxury.

In its present condition, the disc is set into a modern montage, surrounded by filigree in which are embedded enamels from the ninth to twelfth centuries. The noble style of the Crucifixion group agrees with the tenth-century ivories of the Romanos group (Plate 12), even in such small details as the design of Christ's nimbus pattern, and justifies a date in the tenth or not later than the eleventh century.

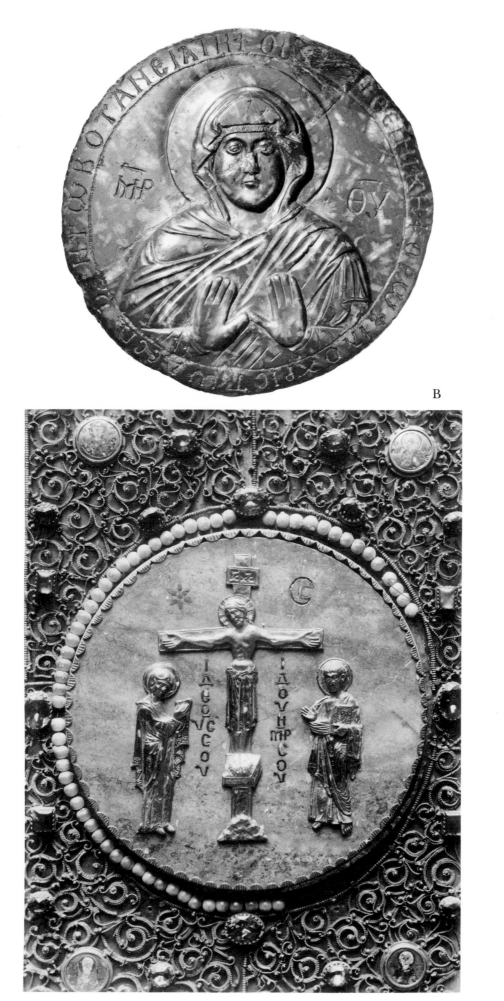

B

C

FIGURE D

PARIS, IVORY WITH NATIVITY

That most Byzantine single ivory plaques still extant were indeed intended to serve as icons is confirmed by this plaque with the Nativity which retains its original setting, embedded in a frame of embossed silver reliefs. Into an ornamental border of typical Byzantine *rinceaux* are inserted fourteen medallions with the *Deësis* in the top center, the Virgin and John the Baptist flanking Christ, whose medallion has been misplaced in the lower right corner (for the *Deësis* see Figure VII), and with eleven Apostles, of which only six remain. This damage is old; some of the missing reliefs were replaced by relics as early as the Gothic period.

The ivory has its own narrow ornamental ivory frame worked separately, and belongs to a group called the "frame group," which evolved from the "painterly group" (Plate 11), and consists mainly of representations of the twelve great feasts of the ecclesiastical year, the Nativity being one of these. Executed in a somewhat sketchy style lacking the perfection of the earlier groups, the plaque must be dated in the eleventh and perhaps the early twelfth century, a date that also fits the silver frame, which thus would seem contemporary.

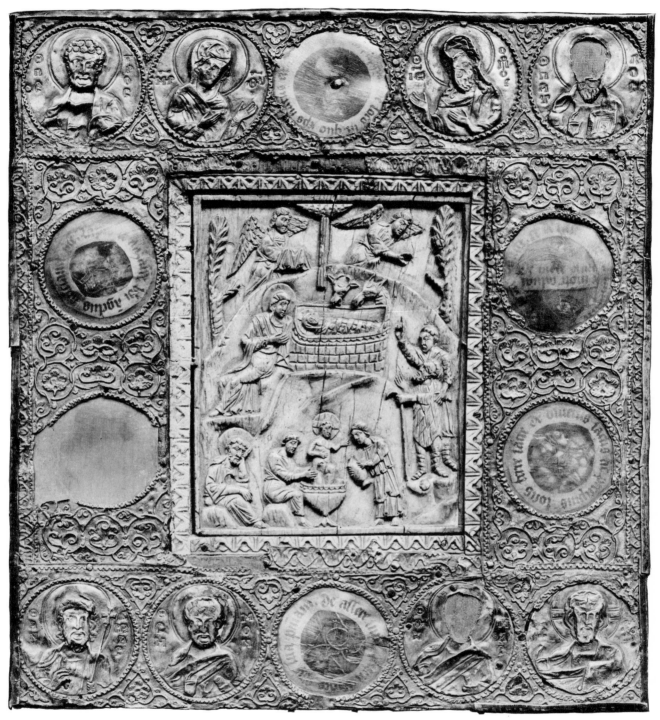

D

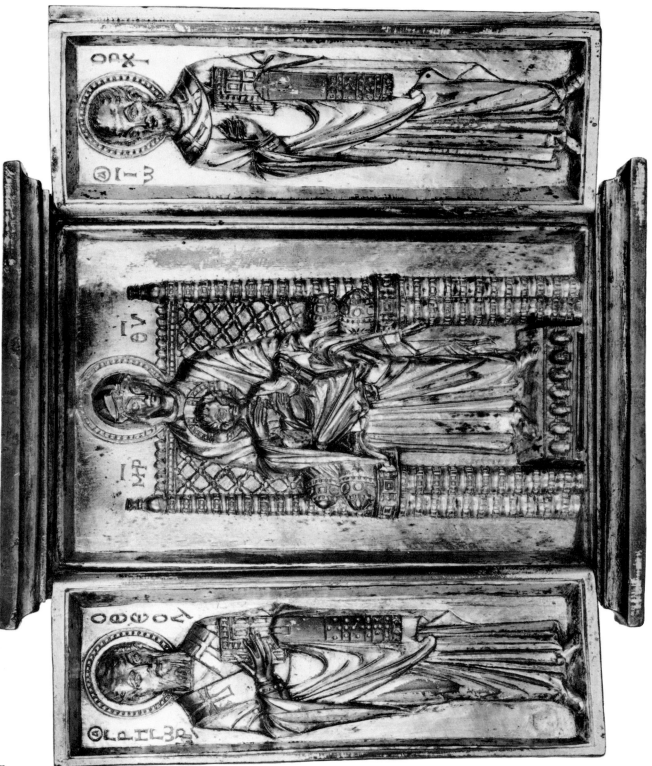

E

FIGURE E

London, Bronze Triptych with Virgin Enthroned

The Virgin with the Christ Child on her lap sits in a hieratic pose on a jewel-studded throne in the center of this triptych, flanked on the wings by the Church Fathers Gregory of Nazianzus and John Chrysostom. In style, the figures are so close to the noble ivories of the Romanos group (Plate 12) that it has been assumed that the bronze was cast on matrices made from ivories. The gilt technique imitates the much more common gold *repoussé*. This kind of bronze casting, rarely seen in Byzantine icons, was apparently employed at a time when ivory itself had become rare, that is, the eleventh to twelfth centuries. The technique of casting would easily explain the survival of a pure tenth-century style in an object which apparently is somewhat later.

FIGURE F

Novgorod, Silver and Painted Icon with Saint Peter and Saint Paul

The frontal figures of Saint Paul holding a codex and Saint Peter holding a cross staff while also pointing at a bust of Christ, are greater than life-size. This unusually large icon was probably placed on a church pillar which had similar icons painted in fresco. One of the very earliest Russian icons, to be dated in the middle of the eleventh century, its style is clearly Byzantine, and yet the size, uncommon in Byzantium, suggests that it may have been made by an itinerant Byzantine artist in Novgorod, if not by a skillful Russian imitating Byzantine style. When the silver cover, the *oklad,* was added, the silversmiths skillfully imitated the painted drapery style and enriched the background and the nimbi with ornament, and the frame with figures of the *Deësis* (Figure D), and Saints, and rich decorative patterns. The purpose of the *oklad* was apparently not merely decorative, but to protect the paint against the soot of candles and incense which, indeed, damaged the heads and hands left free of the silver cover to such an extent that they had to be repeatedly overpainted. The latest overpaint seems to be fifteenth-century; only the garments, after the removal of the *oklad,* reveal the eleventh-century layer of paint.

F

SELECTED BIBLIOGRAPHY

O. Wulff and M. Alpatoff. *Denkmäler der Ikonenmalerei in Kunstgeschichtlicher Folge.* Hellerau bei Dresden, 1925.

N.P. Kondakov and E. P. Minns. *The Russian Icon.* Oxford, 1927.

L. Ouspensky and W. Lossky. *Der Sinn der Ikonen.* Bern and Olten, 1952.

W. Felicetti-Liebenfels. *Geschichte der byzantinischen Ikonenmalerei.* Olten and Lausanne, 1956.

G. and M. Sotiriou. *Icones de Mont Sinai.* Vol I: *Album.* Athens, 1956; Vol II: *Text.* Athens, 1958.

S. Radojčić. *Icones de Serbie et de Macédoine.* Belgrade, 1961.

J. D. Djurić. *Icones de Yougoslavie.* Belgrade, 1961.

H. Skrobucha. *Meisterwerke der Ikonenmalerei.* Recklinghausen, 1961.

W. Weidlé. *Les Icones byzantines et russes.* Milan, 1962.

K. Onasch. *Icons.* London, 1963.

K. Weitzmann, M. Chatzidakis, K. Miatev, and S. Radojčić. *Frühe Ikonen.* Vienna and Munich, 1965; British edition, *Icons from South Eastern Europe and Sinai,* London, 1966; American edition, *A Treasury of Icons,* New York, 1967; other editions in Russian, French, Dutch, and Spanish (1966), Italian (1968), and Yugoslav (1970).

V. Lazarev. *Storia della pittura bizantina.* Turin, 1967.

D. and T. Talbot Rice. *Icons and Their Dating.* London, 1974.

K. Weitzmann. *The Monastery of Saint Catherine at Mount Sinai. The Icons.* Vol I: *From the Sixth to the Tenth Century.* Princeton, 1976.

COLOR PLATES

1. Sinai B.1. Bust of Christ. Sixth century. 84 x 45.5 cm. Sotiriou, *Icones,* I, fig. 174; II, pp. 161–62; M. Chatzidakis, "An Encaustic Icon of Christ at Sinai," *Art Bulletin* XLIX (1967), pp. 197ff. and figs. 1–3; Weitzmann, *Sinai Icons* I, no. B.1, pp. 13ff. and pls. I–II, XXXIX–XLI.

2. Sinai B.3. Virgin Enthroned between Saint Theodore and Saint George. Late sixth century. 68.5 x 49.7 cm. Sotiriou, *Icones,* I, figs. 4–7 and color plate; II, pp. 21ff; Weitzmann et al., *Frühe Ikonen,* pp. IX–X and pls. 1–3, pp. LXXIX, XCVIII; Weitzmann, *Sinai Icons* I, no. B.3, pp. 18ff. and pls. IV–VI, XLIII–XLVI.

3. Berlin, Staatliche Museen. Preussischer Kulturbesitz, Frühchristliche Byzantinische Sammlung, inv. 564/65. Christ between Peter and Paul; Virgin between Two Angels. Sixth century. 29 x 13 and 29 x 12.7 cm. W. F. Volbach, *Elfenbeinarbeiten der Spätantike und des Frühen Mittelalters,* third ed. Mainz, 1976, p. 91 and pl. 71, no. 137; idem, *Avori di Scuola Ravennate nel V e VI seculo.* Ravenna, 1977, p. 22 and fig. 30a–b.

4. Cleveland, Museum of Art 67.144. Virgin Enthroned and Ascending Christ. Sixth century. 179 x 100 cm. D. Shepherd, "An Icon of the Virgin. A Sixth Century Tapestry Panel from Egypt." *Bulletin of the Cleveland Museum of Art* (March, 1969), pp. 90ff.

5. Rome, Funerary Church of Felix and Adauctus in the Commodilla Catacomb. Fresco with Virgin Enthroned between Title Saints and the Widow Turtura. After 528 A.D. 180 x 162 cm. J. Wilpert, *Die römischen Mosaiken und Malereien der kirchlichen Bauten vom IV. bis XIII. Jahrhundert.* Freiburg, 1916, Text II, Pt. II, p. 938; Plate Vol. IV, 136.

6. Rome, Santa Maria in Trastevere. *Madonna della Clemenza.* Seventh-eighth century. 164 x 116 cm. (with frame). C. Bertelli, *La Madonna di Santa Maria in Trastevere.* Rome, 1961.

7. Kiev, City Museum of Eastern and Western Art, no. 113. Saint John the Baptist. Sixth century. 46.8 x 25.1 cm. Brought from Sinai to Kiev in the middle of the nineteenth century by the Archimandrite Porphyry Uspensky. A. Banck, *Byzantine Art in the Collections of the U.S.S.R.* Leningrad-Moscow, 1966, pp. 296, 350, and pls. 111–12; Weitzmann, *Sinai Icons* I, no. B.11, pp. 32ff. and pls. XIV, LVII.

8. Sinai B.5. Saint Peter. First half seventh century. 92.8 x 53.1 cm. Sotiriou, *Icones,* I, figs. 1–3; II, p. 19; Weitzmann et al., *Frühe Ikonen,* pp. X, LXXIX, and pl. 5; Weitzmann, *Sinai Icons* I, no. B.5, pp. 23ff. and pls. VIII–X, XLVIII–LI.

9. Sinai B.43–44. Saint Theodore and Saint George, two wings of a triptych. Ninth–tenth century. Left: 38.6 x 13 cm.; right: 38.6 x 13.5 cm. Sotiriou, *Icones,* I, figs. 30–31; II, pp. 44–45; Weitzmann, *Sinai Icons* I, nos. B.43–44, pp. 73ff. and pls. XXX, XCIX–C.

10. Istanbul, Archaeological Museum 4309. Saint Eudocia. Tenth – early eleventh century. Icon: 57.5 x 27 cm.; matrix: 66 x 28 cm. T. Macridy, "The Monastery of Lips (Fenari Isa Camii)," *Dumbarton Oaks Papers* 18 (1964), p. 273ff. and fig. 79.

11. Berlin, Staatliche Museen. Preussischer Kulturbesitz, Frühchristliche Byzantinische Sammlung, inv. 574. Ivory with the Forty Martyrs of Sebaste. Tenth century. 17.6 x 12.8 cm. A. Goldschmidt and K. Weitzmann, *Die Byzantinischen Elfenbeinskulpturen des X.–XIII. Jahrhunderts.* Vol. II; *Reliefs.* Berlin, 1934, p. 27, no. 10, and pl. III; K. Weitzmann, "The Survival of Mythological Representations in Early Christian and Byzantine Art." *Dumbarton Oaks Papers* 14 (1960), pp. 64–66 and fig. 38.

12. Utrecht, Archepiscopal Museum. Ivory with the Virgin. Middle of tenth century. 25.6 x 13.6 cm. Goldschmidt and Weitzmann, *Byz. Elfenb.* II, p. 39, no. 46, pl. XX (cited for Plate 11 above).

13. Fiesole, Museo Bardini. Steatite with Archangel Gabriel. Eleventh or twelfth century. 15.2 x 10.9 cm. W. F. Volbach, C. Duthuit, and G. Salles, *Art Byzantin.* Paris, 1933, p. 51 and pl. 39A.

14. Venice, San Marco, Treasury. Gold, silver gilt, and enamel icon of the bust of Saint Michael. Second half tenth century. 44 x 36 cm. K. Wessel, *Byzantine Enamels from the 5th to the 13th Century.* Recklinghausen, 1967, p. 89, no. 28; A. Grabar and H. R. Hahnloser in W. F. Volbach et al., *Il Tesoro di San Marco.* Florence, 1971, pp. 25ff., no. 17 and pls. XIX–XXI, CXXVI.

15. Berlin, Staatliche Museen. Kunstgewerbemuseum 27.21. Enamel with Saint Demetrius. Eleventh century.

14.5 x 8.8 cm.
From the Georgian monastery of Djumati and later in the Svenigorodskoi Collection.
K. Wessel, *Byzantine Enamels*, p. 108, no. 36 (cited for Plate 14 above).

16. Munich, Residence, Reiche Kapelle (Wittelsbacher Ausgleichsfonds). Enamel with Crucifixion. Twelfth century. 25 x 18 cm.
K. Wessel, *Byzantine Enamels*, p. 167, no. 51 (cited for Plate 14 above).

17. Sinai. Calendar icon with Saints from the Months of January and February. Second half eleventh century. 26.9 x 28.2 cm.
Sotiriou, *Icones*, I, figs. 139 and 142; II, pp. 121–23.
K. Weitzmann, "Byzantine Miniature and Icon Painting in the Eleventh Century." *Proceedings of the XIIIth International Congress of Byzantine Studies*. Oxford, 1967, p. 220 and pl. 35.

18. Sinai. Moses Before the Burning Bush. Twelfth or possibly thirteenth century. 92 x 64 cm.
Sotiriou, *Icones*, I, fig. 160; II, pp. 140–41.

19. Sinai, Iconostasis beam. Detail with the Raising of Lazarus. First half twelfth century. 44.8 x 114.2 cm.
Sotiriou, *Icones*, I, figs. 87–94; II, pp. 102–105; Weitzmann et al., *Frühe Ikonen*, p. XIV and pls. 25–29, pp. LXXXI–LXXXII; Weitzmann, "A Group of Early Twelfth-Century Sinai Icons Attributed to Cyprus." *Studies in Memory of D. T. Rice*. Edinburgh, 1975, p. 51 and fig. 19a.

20. Sinai. Iconostasis beam. Detail with Miracle of Saint Eustratios. 34.5 x 136 cm.
Sotiriou, *Icones*, I, figs. 103–11; II, pp. 109–10; Weitzmann, *Studies in Memory of D. T. Rice*, pp. 52ff. and figs. 20a–b (cited for Plate 19 above).

21. Moscow, Tretyakov Gallery 14.243. The Virgin of Vladimir. Ca. 1131 A.D. 104 x 69 cm. (with the later, widened frame); painted area 78 x 55 cm. The icon came from Constantinople in 1131 and was first taken to Vyshgorod near Kiev, then in 1155 to Vladimir, and in 1315 to the Kremlin Cathedral of the Assumption in Moscow. In 1919 it was brought first to the Historical Museum and skillfully restored, and finally to the Tretyakov Gallery.
M. Alpatoff and V. Lazareff, "Ein byzantinisches Tafelwerk aus der Komnenenepoche." *Jahrbuch der Preussischen Kunstsammlungen* XLVI (1925), pp. 140–55; A. J. Anisimov, "Our Virgin of Vladimir." *Seminarium Kondakovianum*, Prague, 1928.

22. Sinai. Miracle of Saint Michael. First half twelfth century. 37.5 x 30.7 cm.
Sotiriou, *Icones*, I, fig. 65; II, pp. 79–81; K. Weitzmann, "The Classical in Byzantine Art as a Mode of Individual Expression." *Byzantine Art. An European Art. Lectures*. Athens, 1966, p. 166 and fig. 126.

23. Sinai. Last Judgment. Middle twelfth century. 62.2 x 45.8 cm.
Sotiriou, *Icones*, I, fig. 151; II, pp. 130–31. Weitzmann, *Proc. XIII, Internat. Congress*, pp. 221–22 and pl. 39 (cited for Plate 17 above).

24. Sinai. Iconostasis beam. Detail with Transfiguration. Middle twelfth century. 41.5 x 159 cm. (Fig. VII). This is the central one of three boards, of which the first, with the two feasts of the Virgin and three christological feasts, is also preserved, while the third, with the final five feasts, is lost.
Sotiriou, *Icones*, I, figs. 95–102; II, pp. 105–109; K. Weitzmann, "Byzantium and the West Around the Year 1200." *The Year 1200. A Symposium, Metropolitan Museum of Art*. Dublin. 1975, p. 61 and *passim*, and figs. 14, 17, 20, 22, 24, 30.

25. Sinai. The Heavenly Ladder of John Climacus. Second half twelfth century. 41 x 29.3 cm.
Weitzmann et al., *Frühe Ikonen*, p. XIII and pl. 19; pp. LXXX–LXXXI.

26. Sinai. Crucifixion. Second half twelfth century. 28.2 x 21.6 cm.
Sotiriou, *Icones*, I, fig. 64; II pp. 78–79; Weitzmann et al., *Frühe Iko-* *nen*, p. XII and pl. 21; p. LXXXI.

27. Sinai. Annunciation. End twelfth century. 61 x 42 cm. (without the later bottom strip).
K. Weitzmann, "Eine spätkomnenische Verkündigungsikone des Sinai und die zweite Byzantinische Welle des 12. Jahrhunderts." *Festschrift für Herbert von Einem*, Berlin, 1965, pp. 299ff.; Weitzmann et al., *Frühe Ikonen*, p. XVI and pl. 30; p. LXXXII.

28. Paris, Louvre ML. 145. Mosaic icon with the Transfiguration of Christ. Turn of twelfth to thirteenth century. 52 x 36 cm.
E. Coche de la Ferté, *L'Antiquité Chrétienne au Musée du Louvre*. Paris, 1958, p. 70, 117 no. 74; H. Skrobucha, *Meisterwerke der Ikonenmalerei*. Recklinghausen, 1961, p. 65 and pl. IV.

29. Sinai. The Prophet Elijah. Around 1200 A.D. 130 x 67 cm.
Sotiriou, *Icones*, I, fig. 74; II, pp. 88–89; Weitzmann, *Byzantine Art*, pp. 172ff. and fig. 135 (cited for Plate 22 above); idem, *The Year 1200*, pp. 63, 68, and figs. 25, 37 (cited for Plate 24 above).

30. Sinai. Isaiah and the Virgin. Early thirteenth century. 23 x 18.5 cm.
Sotiriou, *Icones*, I, fig. 163; II, p. 143; Weitzmann, "Loca Sancta and the Representational Arts of Palestine." *Dumbarton Oaks Papers* 28 (1974), p. 53 and figs. 48–49.

31. Sinai. Iconostasis beam. Detail with the Raising of Lazarus. Early thirteenth century. 39 x 18.5 cm.
Sotiriou, *Icones*, I, figs. 112–16; II, pp. 111–12; Weitzmann, *The Year 1200*, pp. 60 and *passim*, and figs. 1, 21–23, (cited for Plate 24 above).

32. Sinai, Mosaic icon with Virgin and Child. Early thirteenth century. 44.6 x 33 cm (without frame, 34 x 23 cm.).
Sotiriou, *Icones*, I, pl. 71; II, pp. 85–87; Weitzmann et al., *Frühe Ikonen*, p. XVII and pl. 36; p. LXXXIII.

33. Sinai. Bust of Saint Nicholas. First

half thirteenth century. 82 x 56.9 cm.
Sotiriou, *Icones,* I, fig. 165; II, pp. 144–47; K. Weitzmann, "Fragments of an Early St. Nicholas Triptych on Mount Sinai." *Deltion tes Christian kes Archaiologikes Hetaireias,* Per. IV, Vol. IV (1964–66). Athens, 1966, pp. 6ff. and fig. 6.

34. Sinai. Saint George. First half thirteenth century. 127 x 78.5 cm.
Sotiriou, *Icones,* I, fig. 167; II, pp. 149–51.

35. Athens, Byzantine Museum Inv. 89. Wooden relief icon of Saint George. Thirteenth century. 109 x 72 cm. Formerly Kastoria in Greek Macedonia.
G. Sotiriou, "La Sculpture sur bois." *Mélanges Charles Diehl.* vol II. Paris, 1930, pp. 178ff. and pl. XV; R. Lange, *Die Byzantinische Reliefikone.* Recklinghausen, 1964, pp. 121ff., no. 49; M. Chatzidakis in Weitzmann et al., *Frühe Ikonen,* p. XXVI and pl. 49; p. LXXXIII.

36. Sinai. Bust of Moses (detail). Third quarter thirteenth century. 34.3 x 23.8 cm.
Sotiriou, *Icones,* I, fig. 195; II, p. 178; cf. also K. Weitzmann, "Thirteenth-Century Crusader Icons on Mount Sinai." *Art Bulletin* XLV (1963), pp. 189ff. and figs. 9–18.

37. Sinai. Left wing of a Diptych. Detail with bust of Saint Procopius. Third quarter thirteenth century. 50.6 x 39.7 cm.
Sotiriou, *Icones,* I, pls. 188–90; II, pp. 171–73; K. Weitzmann, "Icon Painting in the Crusader Kingdom." *Dumbarton Oaks Papers* 20 (1966), pp. 66ff. and figs. 33–39.

38. Sinai. Crucifixion. Third quarter thirteenth century. 120.5 x 67 cm.
Weitzmann, *Art Bulletin* (1963), pp. 183ff. and figs. 5–6 (cited for Plate 36 above); idem, *Dumbarton Oaks Papers* 1966, p. 64ff. and figs. 26–28 (cited for Plate 37 above).

39. Sinai. Saint Antipas. Second half thirteenth century. 58.2 x 44.9 cm.
M. Chatzidakis and A. Grabar, *Byzan-*

tine and Early Medieval Painting. London, 1965, pl. 52.

40. Sinai. The Death of the Virgin. Second half thirteenth century. 44.4 x 33.4 cm.
Weitzmann, *Dumbarton Oaks Papers* 1966, p. 65 and figs. 29, 30 (cited for Plate 37 above).

41. Washington, D.C., Dumbarton Oaks 47.24. The Forty Martyrs of Sebaste. Turn of thirteenth–fourteenth century. 22 x 16 cm.
O. Demus, "Two Palaeologan Mosaic Icons in the Dumbarton Oaks Collection." *Dumbarton Oaks Papers* 14 (1960), pp. 96ff. and figs. 1–3; K. Weitzmann, "The Survival of Mythological Representations in Early Christian and Byzantine Art and Their Impact on Christian Iconography." *Dumbarton Oaks Papers* 14 (1960), p. 66 and fig. 41.

42. Moscow, The Pushkin Museum of Fine Arts 2851. The Twelve Apostles. Early fourteenth century. 38 x 34 cm.
O. Wulff and M. Alpatoff, *Denkmäler der Ikonenmalerei.* Hellerau bei Dresden, 1925, p. 114 and fig. 43; p. 270; A. Banck, *Byzantine Art in the U.S.S.R.,* p. 375 and pl. 254 (cited for Plate 7 above).

43. Sinai. Triptych wing with Saint George, John of Damascus, and Ephraim Syrus. Early fourteenth century. 21.4 x 9.5 cm.
Sotiriou, *Icones,* I, figs. 62–63; II, pp. 77–78; Weitzmann, *Dumbarton Oaks Papers* 1966, p. 58 and fig. 13 (cited for Plate 37 above).

44. Ohrid, National Museum. Bilateral icon with the bust of the Virgin and Annunciation. Early fourteenth century. 94.5 x 80.3 cm. Comes from the Peribleptos Church (Saint Clement) in Ohrid.
S. Radojčić, in Weitzmann et al., *Frühe Ikonen,* p. LXV and pls. 161–65. p. XCIII; Djurić *Icones de Yougoslavie,* pp. 91–92, no. 14, and pls. XVII–XXI.

45. London, Victoria and Albert Museum 7231–1860. Mosaic icon

with the Annunciation. Middle fourteenth century. 13.3 x 8.4 cm.
D. T. Rice, *The Art of Byzantium.* London, 1959, p. 336 and pl. XXXVIII; J. Beckwith, *The Art of Constantinople.* Greenwich, Conn., 1961, p. 137 and fig. 181.

46. Athens, Benaki Museum. The Hospitality of Abraham. End fourteenth century. 33 x 60 cm.
Chatzidakis, in Weitzmann et al., *Frühe Ikonen,* p. XXXIV and pls. 78–79; pp. LXXXV–LXXXVI.

47. Sofia, National Gallery 2057. Virgin and Saint John. After 1395 A.D. 93 x 61 cm.
A. Grabar, "A Propos d'une icone byzantine du XIVe siècle." *Cahiers Archéologiques* X (1959), pp. 289ff. and figs. 1, 3; K. Miatev, in Weitzmann et al., *Frühe Ikonen,* p. XLVIII, pls. 102–105; p. LXXXVII.

48. Sinai. Bust of John the Baptist. End fourteenth century. 24.7 x 19 cm.
K. Weitzmann, "Mount Sinai's Holy Treasures." *National Geographic Magazine,* Jan. 1964, fig. p. 117.

BLACK AND WHITE FIGURES

I. Moscow, Historical Museum. Cod. gr. 129, fol. 67r. Psalter. Ninth century. 20 x 15.5 cm.
A. Grabar, *l'Iconoclasme Byzantin*. Paris, 1957, fig. 146.

II. Mount Sinai. Cod. gr. 418, fol. 269r. The Heavenly Ladder of John Climacus. Eleventh – twelfth century. 17 x 13.5 cm.
J. R. Martin, *The Illustration of the Heavenly Ladder of John Climacus*. Princeton, 1954, p. 101 and pl. LXXV, fig. 213.

III. Paris, Louvre. P.202. 55 x 44 cm. First half of fourth century. Female Portrait. Probably found in the Fayyum.
Koptische Kunst. Christentum am Nil. Exhibition, Essen, 1963. Catalogue no. 45 and color plate.

IV. Berlin, Staatliche Museen. Diam. 30.5 cm.
Panel in tempera(?) with Septimius Severus, Julia Domna, Caracalla, and Geta (face obliterated). Third century. K. A. Neugebauer, "Die Familie des Septimius Severus." *Die Antike* XII (1936), p. 155ff. and color plate.

V. Malibu, California, J. Paul Getty Museum 74–Al–21–22. Tempera on wood. Third century. Sarapis: 39 x 19 cm. ; Isis: 40 x 19 cm.
At present the wings flank a devotional box which encloses a male funerary portrait.
J. Frel, *Recent Acquisitions in Ancient Art, The J. Paul Getty Museum, Malibu California*. Exhibition catalogue. Washington State University, 1974, nos. 23–24.

VI. Mount Sinai, Saint Catherine's Monastery. Interior view. G. H. Forsyth and K. Weitzmann, *The Monastery of Saint Catherine at Mount Sinai. The Church and Fortress of Jus-tinian*. Ann Arbor, n.d. (1973), pls. XLIII, LVIII–LX.

VII. Mount Sinai. Center of an iconostasis beam with Baptism, Transfiguration (Plate 24), *Deësis*, Raising of Lazarus and Entry into Jerusalem. Twelfth century. 41.5 x 159.5 cm. G. and M. Sotiriou, *Icones* I, figs. 95–98; II, pp. 105–106.

A. Venice, Santa Maria Mater Domini. Marble icon of the Virgin. Eleventh century. 136 x 76 cm.
R. Lange, *Die Byzantinische Reliefikone*. Recklinghausen, 1964, p. 52, no. 6.

B. London, Victoria and Albert Museum A.1–1927. Disc in serpentine with bust of Virgin. 1078–1081 A.D. Diam. 17.9 cm. From the Abbey of Heiligenkreuz, Austria.
F. W. Volbach and J. Lafontaine-Dosogne, *Byzanz und der Christliche Osten*. Berlin, 1968, p. 202, no. 102c.

C. Venice, Treasure of San Marco Inv. 2. Disc with golden Crucifixion on lapis lazuli. Tenth – eleventh century. Icon: 42 x 31 cm.; Disc: ca. 14.7 cm.(diam.).
A. Grabar, in W. F. Volbach et al., *Il Tesoro di San Marco*. Florence, 1971, p. 28, no. 19, pl. XXIII.

D. Formerly Paris, Collection Marquis de Vasselot. Ivory icon with Nativity. Eleventh–early twelfth century. 26.3 x 23.4 cm. Ivory: 12.3 x 10.3 cm.
A. Goldschmidt and K. Weitzmann, *Die Byzantinischen Elfenbeinskulpturen des X–XIII Jahrhunderts*. Vol. II: *Reliefs*. Berlin, 1934, p. 73 and pl. LXV.

E. London, Victoria and Albert Museum, 1615–1855. Bronze gilt triptych with Virgin enthroned. Eleventh–twelfth century. 16.5 x 9 cm. (closed); 19 cm. (open).
W. F. Volbach, C. Duthuit and G. Salles, *Art Byzantin*. Paris, 1933, p. 63 and pl. 58.

F. Novgorod, Museum of History and Architecture. Formerly in the Cathedral of Saint Sofia in Novgorod. Saint Peter and Saint Paul. Middle of eleventh century. 236 x 147 cm.
V. N. Lazarev, *Novgorodian Icon Painting*. Moscow, 1969, pp. 6–7 and pls. 1–2; A. Grabar, *Les Revêtements en or et en argent des icones Byzantines du Moyen Age*. Venice, 1975, p. 23 and figs. 3–5.

PLATES AND COMMENTARIES

PLATE 1

SINAI, ENCAUSTIC ICON WITH BUST OF CHRIST

The first of three great early masterpieces from Sinai (Plates 2 and 8) depicts a bust of Christ, almost life-size, holding a jewel and pearl-studded Gospel book in his left arm and blessing with his right. Its beauty was revealed only after the removal of thick overpaint in 1962. It is on the whole well preserved; only the hair on the left side of Christ's head has a restored patch. The tunic and mantle are depicted in the imperial purple, and the bust is placed in front of a niche with slit windows, above which is seen a sky shaded from darker to lighter blue. The panel has been trimmed at the top and both sides, more to the left than to the right, so that Christ is no longer on the axis of the panel as he originally had been—a loss that has slightly impaired the icon's hieratic quality. Moreover, the panel originally had a separately worked frame, probably with an inscription which may well have included the donor's name.

The high quality of this icon rests both on the subtle, refined, and lively rendering of the flesh areas, which still display a full command of the classical tradition, and on the artist's ability to transcend Christ's human nature by conveying the impression of aloofness and timelessness associated with the Divine. Yet rigidity is avoided by a striking asymmetry, evident in the pupils of the wide open eyes, the arching of the brows, the treatment of the mustache, and the combing of the beard, as well as the flow of the hair. We presume that such outstanding quality points to Constantinople as the panel's place of origin. The Monastery of Saint Catherine was an imperial foundation of Justinian, but since contacts with the Capital were interrupted for centuries beginning in 640 with the conquest of Sinai by the Muslims, we believe that all three early Sinai icons must have been executed before this date, with the Christ icon the earliest of the three, reaching back to the sixth century.

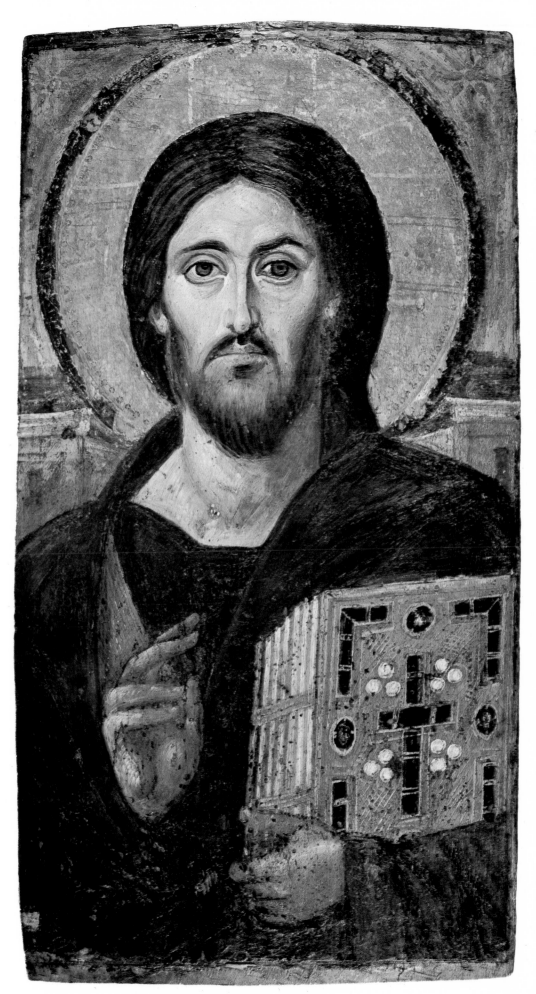

1

PLATE 2

SINAI, ENCAUSTIC ICON WITH VIRGIN FLANKED BY SAINT THEODORE AND SAINT GEORGE

The second early Sinai masterpiece depicts the Virgin enthroned with the Christ Child seated in her lap, flanked by two soldier saints, the bearded General Theodore Stratelates at her right, and the youthful Saint George at her left, while two archangels stand behind her looking up toward the hand of God in heaven from which a beam of light descends upon the Virgin. Except for a few patches, the encaustic painting is in remarkably good condition. The only serious evident loss is in the separately-worked frame, which quite certainly bore an inscription.

The Virgin, dressed in a purple maphorion, is rendered in a slightly contrappostic pose with her knees turning in one direction and her eyes in the other. Christ, dressed in gold-hatched ochre garments, sits on the Virgin's lap in a babyish pose, although his head is characterized by a large forehead suggesting maturity and spiritual power. In contrast to this relative freedom of movement, the two soldiers stand immovable, like flanking pylons. The artist purposely used three different modes for the characterization of the figures: the olive-colored shadows in the Virgin's face and her glance to the side suggesting aloofness are appropriate to the Divine; the realistic, sunburned face of Saint Theodore and the pallid face of Saint George are appropriate to these soldier saints; and the transparent nimbi and the faces and garments of the angels, in fleeting, impressionistic brush strokes revealing early classical models, have an ethereal quality proper to their incorporeality. Like the preceding Christ icon, the figures are placed before a niche which, however, rises almost to the upper border and has thus largely lost its space-creating function. For this reason we believe this icon, which also is quite assuredly the product of a Constantinopolitan workshop, was painted later in the sixth century.

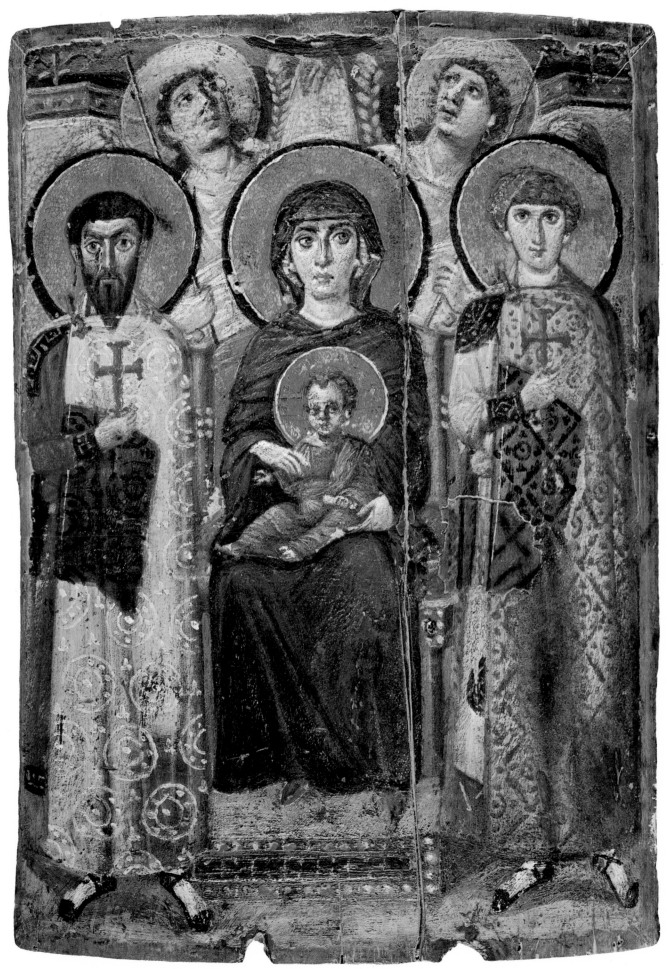

2

PLATE 3

BERLIN, IVORY DIPTYCH WITH CHRIST AND THE VIRGIN

The Virgin with Child on the right wing invites comparison with the roughly contemporary Sinai icon (Plate 2). On the one hand, this Virgin in carved ivory is a more stately matron, with a full, fleshy face and more clearly marked bodily forms. On the other hand, her seated pose is more ambiguous, with the Christ Child not firmly resting in her lap, but looking rather suspended and dematerialized. The flanking archangels in military garb, quite assuredly Michael and Gabriel, are physically closer to the soldier saints than to the ethereal beings in the Sinai icon.

Christ dominates the left wing, blessing and holding a huge jewel-studded Gospel book, like those placed on the altar table and thus alluding to a distinct liturgical implement. His long beard and hair are those of Christ as the Ancient of Days (Daniel 7:22), and in a painting would appear white. He is flanked by Saint Peter and Saint Paul.

The more secular appearance of these panels is due to the marked influence of contemporary ivory consular diptychs, in which the consul sits upon the so-called *sella curulis* instead of a high-backed throne, and before a similar, highly decorative arch derived from palace architecture.

The bottoms of both plaques have been trimmed. Here monograms existed, of which only the top sigmas remain; it has been assumed that the monograms were those of Maximianus, who was Bishop of Ravenna in the middle of the sixth century. For him was made the famous ivory cathedra to which this diptych is closely related in style, and it is quite possible that both works were made in Ravenna either by Constantinopolitan artists or local carvers trained by them.

While the Berlin diptych was used at a later time for liturgical purposes (there are prayers from the Carolingian period written on the back of each wing), the original purpose we believe was devotional. While it does not have the same degree of spirituality and aloofness as the Sinai icon, it still has that powerful hieratic quality, which is the very essence of an icon.

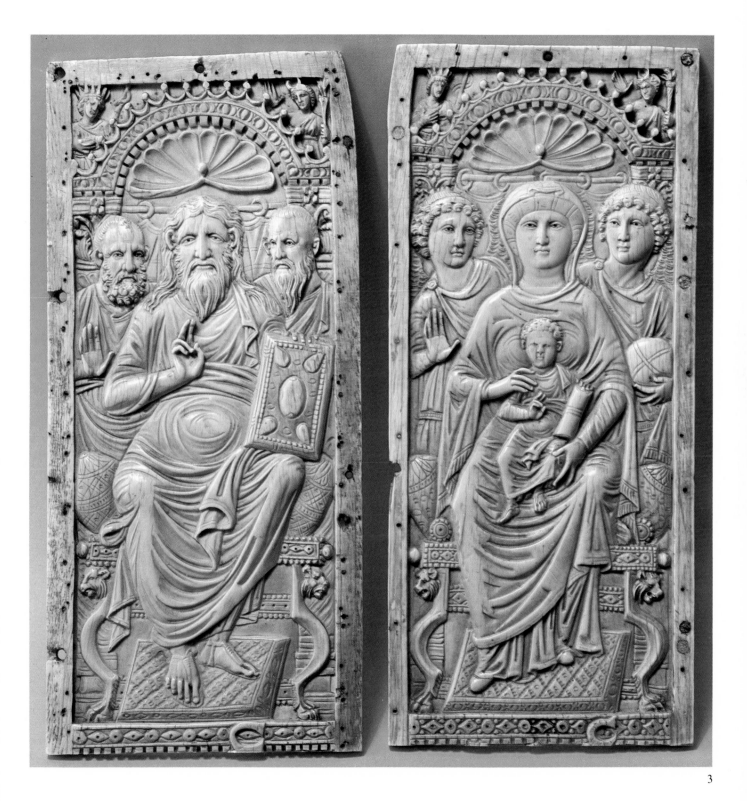

3

PLATE 4

Cleveland, Tapestry with Virgin Enthroned

In this colorful tapestry the enthroned Virgin is depicted dressed in the imperial purple and seated on a jewel-studded throne, as in the Sinai icon (Plate 2), while the Christ Child in her lap is suspended, as in the Berlin ivory (Plate 3), with which the tapestry also shares an architectural, though much simplified, setting. And as in the ivory, the Virgin is flanked by the two archangels, here inscribed "Michael" and "Gabriel". In an upper zone the depiction of Christ enthroned in a mandorla and being carried up to heaven by two angels has been taken from an Ascension scene. This combination of the Ascension with the Virgin enthroned is found in Egyptian frescoes. A decorative border filled with fruit and flowers contains in the lower zone medallions of the twelve Apostles, as is common in contemporary monumental art such as the apse mosaic in Saint Catherine's Monastery at Mount Sinai, where Apostle and Prophet medallions frame a Transfiguration scene.

Less refined than the Sinai icon and the Berlin ivories, which reflect the style of Constantinople, this tapestry, surely made in Egypt during the sixth century, shows a more rustic style found in much of Coptic art, its effectiveness stemming from its more abstract design and strong coloration. The abstraction is particularly clear in the suspension of throne and footstool, making the feet of the angel at the left visible below, and, furthermore, in the insecurity of the proportions, as seen in the oversized heads of the Virgin and angels and in the red cushion placed behind rather than underneath the Virgin. The impact of the medium is apparent in the choice of red as background color—only a small strip filled with stars is a heavenly blue.

While there exist a few other textile fragments with figures of saints, this is the only large-scale hanging that is a well-preserved icon, reminding us of the story of Bishop Arculf, who visited Jerusalem in the seventh century and saw there a woven icon of Christ and the twelve Apostles.

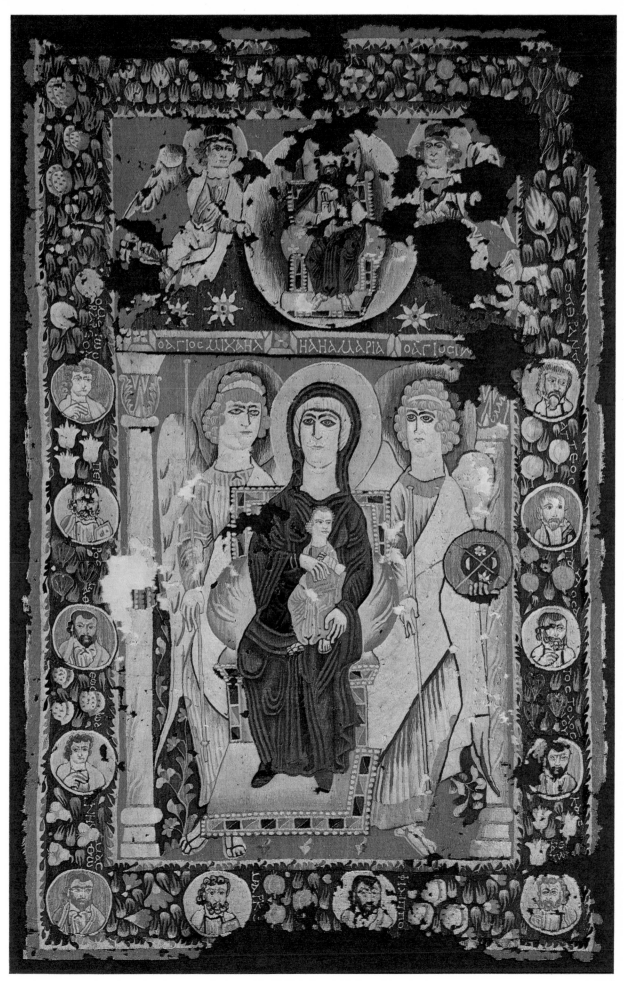

4

PLATE 5

ROME, FRESCO WITH VIRGIN ENTHRONED, FLANKED BY SAINT FELIX AND SAINT ADAUCTUS

It is hardly surprising that among the few early icons no subject occurs more frequently than the Virgin and Child. After the Council of Ephesus in 431 had declared her the *Theotokos*, the Mother of God, there developed a cult of the Virgin that found its outlet in a majestic type of icon portraying the purple-clad Virgin seated on a jewel-studded throne with a golden-clad Christ Child in her lap and flanked either by saints (Plate 5), angels (Plates 3, 4, and 6), or both (Plate 2). In this iconic fresco in the Commodilla Catacomb in Rome, she is flanked by the two title saints of the funerary chapel—Saint Felix, much resembling Saint Peter, to her left, and the youthful Saint Adauctus to her right. The novel feature in this fresco is the inclusion of the widow Turtura, in whose honor the fresco was dedicated by her son. With veiled hands she devotedly offers an open scroll to the Virgin, thus visually emphasizing the purpose of this votive icon. A marble inscription found nearby with her name and that of a consul of the year dates the fresco 528 A.D.

Obviously influenced by such Byzantine panels as the Sinai icon (Plate 2), this fresco has the same hieratic, self-contained quality, but there are slight stylistic differences due to the fact that the fresco was executed by a Roman artist. The poses of both Virgin and Child are more rigid, and worldly splendor is more highly emphasized in the ostentatious display of jewels on the throne. At the same time, the fresco Virgin, though with a somewhat blank stare, looks at the beholder, establishing direct contact, whereas the Sinai Virgin is aloof and unaware of the beholder. Moreover, whereas the Eastern painter employed a more painterly technique reminiscent of a classical style and aiming at impressionistic effects, the Western artist adopted an almost harsh linear style.

At a later period, as in the mosaics of Monreale from the end of the twelfth century, this Virgin type would be inscribed *Panachrantos*, that is, the Immaculate, a meaning which well fits our fresco Virgin, although at this early time such epithets were not employed.

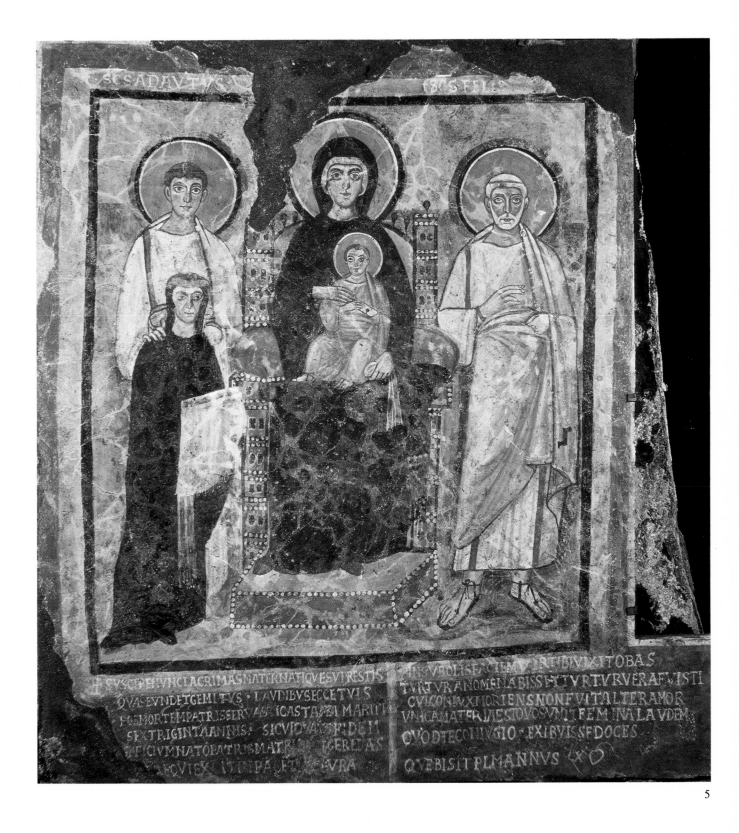

PLATE 6

Rome, Encaustic Icon with Madonna and Angels

One of the holiest icons of Rome, in Santa Maria in Trastevere, is that of the Virgin called *La Madonna della Clemenza*. It was believed to be a work of the thirteenth century until 1953 when restoration was begun which revealed, under the later overpaint, an early encaustic icon which has been dated around the seventh to eighth century, perhaps more precisely during the period of John VII (705–707), a Greek on the papal throne. It is yet another variant of the Virgin enthroned between the archangels who, in their slightly receding poses, resemble those of the Berlin ivory (Plate 3) save that they are draped in tunic and mantle. But what distinguishes this Virgin from the others seen so far are her pearl-studded crown with *pendulia*, her necklace, and the pearl-embroidered hems of her garment, obviously the adornments of a Byzantine empress. The same, slightly earlier, type occurs among the frescoes in Santa Maria Antiqua in Rome where she is inscribed *Regina Coeli* (Queen of Heaven). This concept of the heavenly queen is familiar in Greek and Latin literature alike, but in Byzantine art the Virgin never wears a crown, her purple garments and shoes being the only indications of her imperial status. Her jewel-studded cross staff is also a Western element. All this makes it quite clear that, despite Byzantine inspirations, the West had begun to develop its own iconography and style.

Partly conditioned by a format of unusual verticality, the Virgin is rendered in such over-elongated proportions that at first glance it seems ambiguous whether she is standing or seated, although the indication of a bent knee and the Christ Child seated on her lap leave no doubt. A comparison with the Sinai Virgin (Plate 2) makes one realize how far from the Hellenistic-Byzantine wellspring the Western artist had moved to achieve an utmost hieratic quality at the expense of organic body treatment.

A separately worked frame—which the Sinai icons in Plates 1 and 2 also had—contains in iambic trimeter a praise of the Virgin, comparable to the so-called Acathistos Hymn in Byzantium.

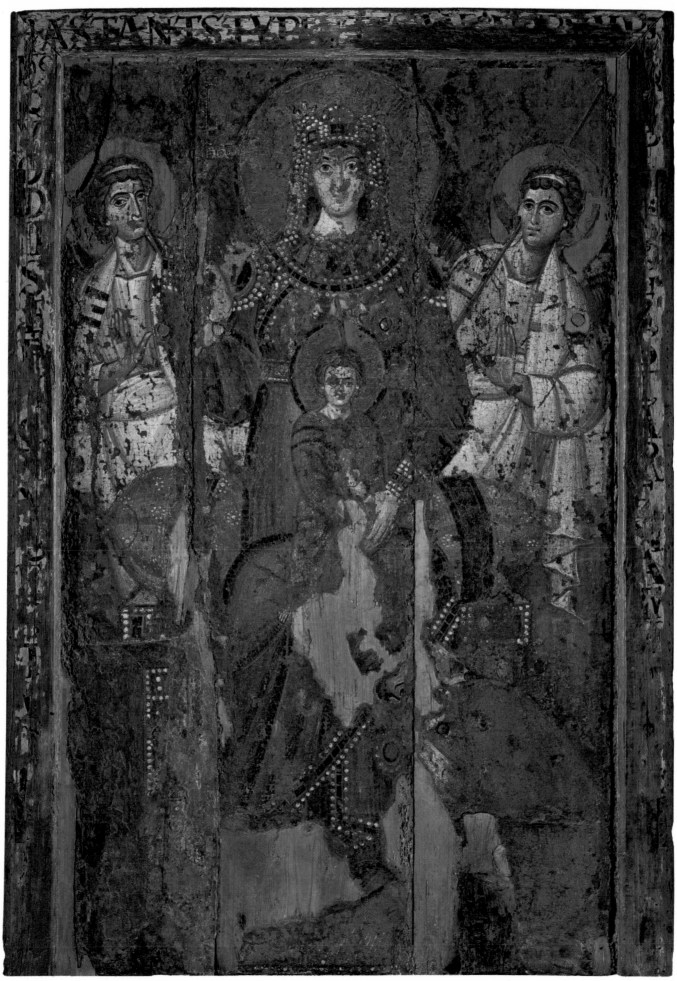

PLATE 7

KIEV, ENCAUSTIC ICON WITH SAINT JOHN THE BAPTIST

After Christ and the Virgin, Saint John the Baptist is mentioned next in the Prayer of Intercession. In this icon at Kiev, his role as the Precursor is made clear by the open scroll in his left hand, which reads in Greek, "Behold the Lamb of God, which taketh away the sins of the world" (John 1:29). Although he stands at ease in a frontal pose, a narrative context is indicated by his raised hand—mostly destroyed—which points toward Christ, depicted in a medallion bust in the upper left corner; in a fuller development of this theme, Christ would be full-size and would approach Saint John. In the upper right is a medallion bust of the Virgin, uncalled for in this context, but of liturgical significance. In this triad the Virgin and John are the intercessors, she for the new and he for the old dispensation; the three together thus form what is called the *Deësis* (the Supplication) in its earliest and not yet fully developed form (Figure VII).

As the Prophet in the wilderness, Saint John the Baptist is depicted with dishevelled hair in somber brown tunic and mantle, wearing in addition between the two the *melote,* a sheepskin in olive grey. The same color is also used for his emaciated face, expressing pain befitting the tragic Prophet.

The highlights in the face underlining John's visionary power and the fleeting brush strokes on his garments still reflect strongly the classical tradition. We see here one of the oldest icons in existence: whether it could belong to the fifth century is an open question, and more safely we may ascribe it to the sixth. We do not know where the icon might have been painted. Since it is so different in style from the three great masterpieces (Plates 1, 2, and 8) that we attribute to Constantinopolitan workshops, we hesitate to propose an origin in the Capital for this icon and consider Palestine a possible place of origin.

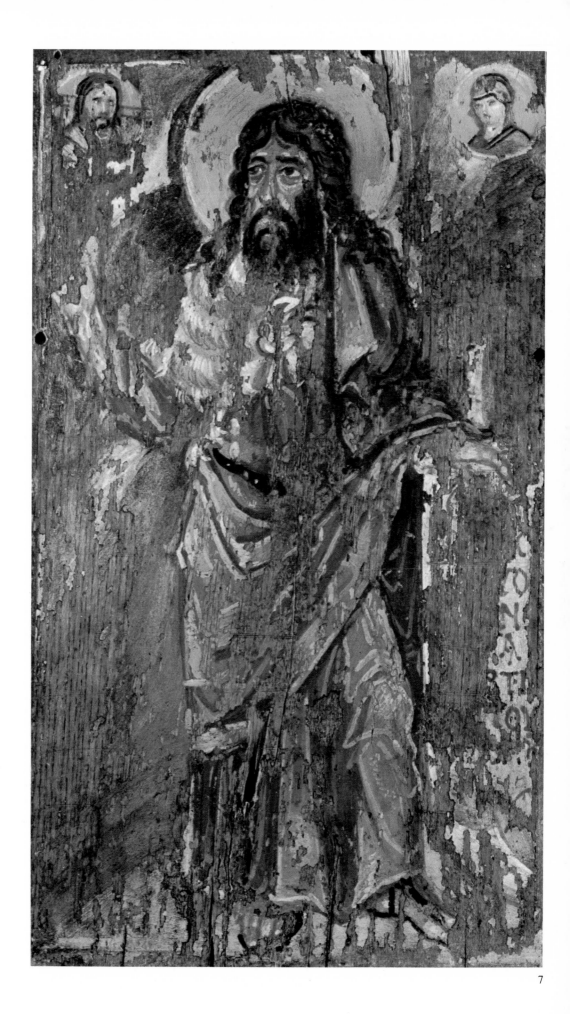

PLATE 8

SINAI, ENCAUSTIC ICON WITH SAINT PETER

The third of the three great early masterpieces from Sinai depicts an almost life-size bust of Saint Peter, dressed in olive-colored tunic and mantle, holding a cross staff in his left hand and clutching three keys in his right. Like the Christ and the Virgin (Plates 1 and 2), he is placed within a niche which is more decorative than space-creating, but which gains in reality by showing the sky changing from darker to lighter blue. At the top are three medallions with Christ in the center, the veiled Virgin at the right, and a youthful saint, in all probability Saint John the Evangelist, at the left. The composition is clearly inspired by imperial art, namely the sixth-century Constantinopolitan consular diptychs in ivory with the consul holding in his left hand a scepter, as Saint Peter holds the cross staff, and a *mappa* in his right hand, as the Apostle holds the keys. Moreover, the three medallions at the top take the place of the emperor in the center, the empress at the right, and the co-consul at the left, as in the consular diptychs.

What is most striking is Saint Peter's expressive and spiritual face, not that of a fisherman but of the intellectual leader of the Church. Although the large eyes radiate calm and concentration, the whirling tuft of hair and the beard combed to one side reveal emotion and excitability.

We have here the work of a master who skillfully exercised control by using warm red-brown flesh tones with great subtlety and gradation, while applying daring free brush strokes to the garments, whose highlights, though still reflecting the effects of light, have begun to assume a decorative pattern, in this respect going beyond the Christ and the Virgin icons (Plates 1 and 2). It is for this reason that we assume a somewhat later date for Saint Peter, most likely during the first half of the seventh century. The following generations of Byzantine painters who went to Rome to work in Santa Maria Antiqua were to develop these crisscrossing highlights in an increasingly abstract manner over more dematerialized bodies.

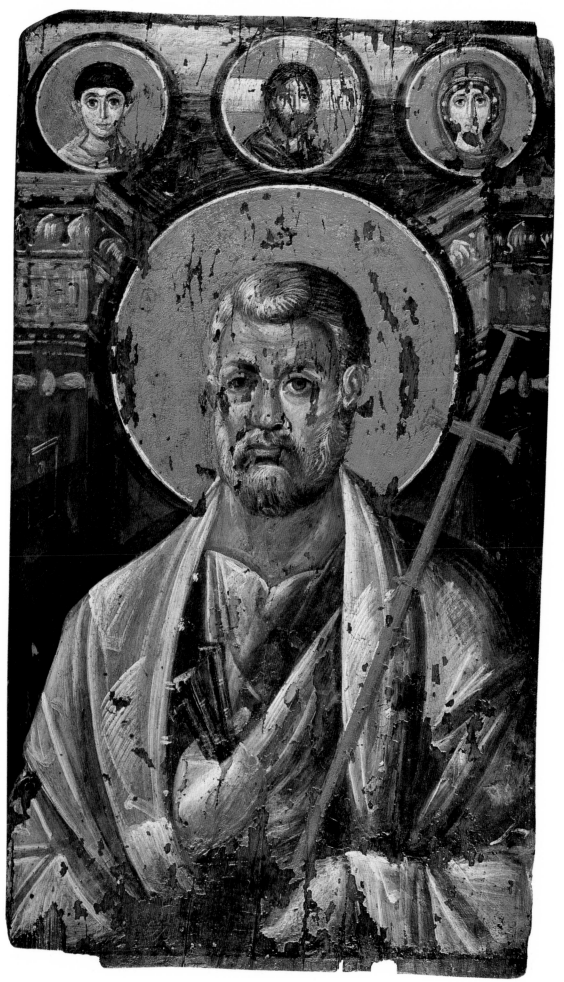

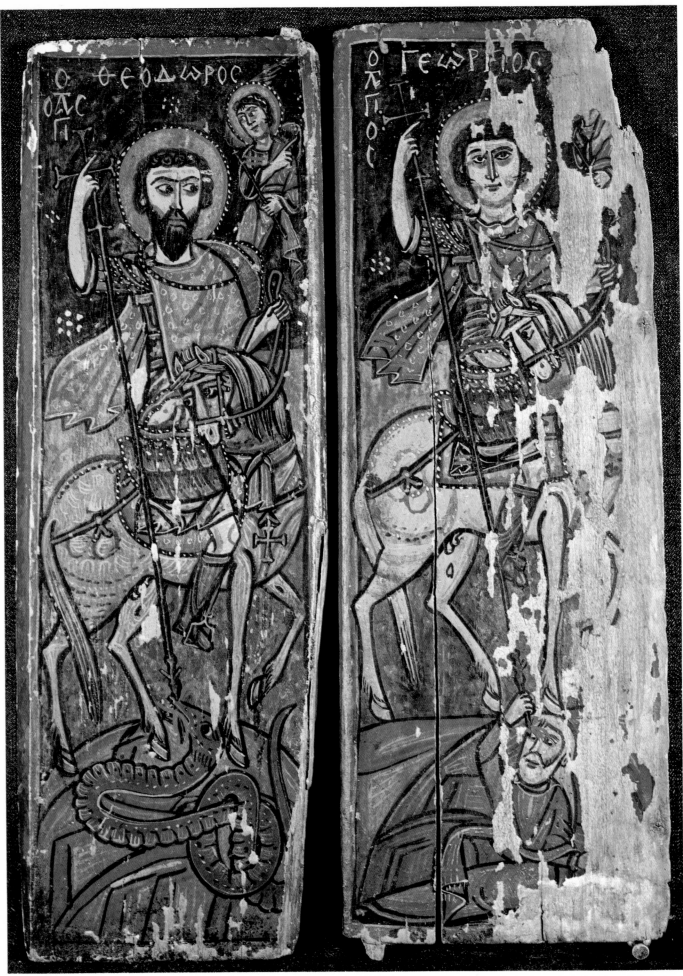

PLATE 9

SINAI, TRIPTYCH WINGS WITH SAINT THEODORE AND SAINT GEORGE

The two wings depict the same two soldier saints, Saint Theodore and Saint George, as shown in the Virgin icon (Plate 2), the one with a pointed beard and the other youthful; yet instead of standing in ceremonial court garments, they are outfitted here with Roman armor and are mounted on horses from which they pierce their victims with lances. Instead of Saint George, as is usual, it is Saint Theodore who kills the dragon, a knotted serpent, while Saint George pierces the forehead of an old man seated on the ground. This latter iconography, foreign to Byzantine art, is quite popular in Georgia, where, on an eleventh-century silver *repoussé* icon, the defeated old man is inscribed "the godless king Diocletian." Apparently we see here a work produced under Georgian influence, quite easily explainable at Sinai, in whose monastery a colony of Georgian monks resided for several centuries.

The pose of the "Rider Saints" is not so much that of soldiers in battle as of victorious warriors on horses in parade step. Saint George's lance is touched by the defeated enemy as a gesture of submission. The angels in the upper corners of the triptych wings point to Christ in the Ascension of the central panel, which is now separated. As in the Saint Peter icon (Plate 8), we also see in these triptych wings the strong impact of imperial iconography.

The panels belong to a larger group of Sinai icons which quite certainly were made in Palestine and perhaps in Sinai proper, then part of Palestine, at a time when this part of the world had been cut off from the Byzantine homeland after the Islamic conquest. These icons reflect a style quite removed from the classical tradition. The restricted color scale is typical, showing a preference for reds and browns and inclined toward decorative adornment with circle and star patterns on the garments and ground. Harsh, yet expressive in their simple linear design, these wings, which may be attributed to the ninth or tenth century, show qualities comparable to fifteenth-century Western woodcuts.

PLATE 10

Istanbul, Marble Intarsia with Saint Eudocia

Excavations in the Monastery of Lips, the present Fenari Isa Camii in Istanbul, have brought to light a considerable number of fragments of icons in marble inlay, the so-called *opus Alexandrinum,* but the only one completely preserved is this one depicting Saint Eudocia. These icons belong to a period either contemporary with or not much later than the foundation of the church—the tenth or perhaps early eleventh century.

The daughter of an Athenian philosopher, herself a poetess known by the pagan name Athenais, Eudocia, wife of Theodosius II (408–450), became a devout Christian and is remembered in the church on August 13 for having brought the chains of Saint Peter and the relics of Saint Stephen from Jerusalem to Constantinople. Crowned and dressed in the full regalia of an empress, including the so-called *thorakion,* the shield-like drapery over her hips, she is rendered as an Orant in a strongly hieratic pose. The matrix is white marble, into which colored pieces of marble, paste, and glass are set—pink for the flesh tones, yellow for the halo to imitate gold, dark red-brown for the garments suggesting the imperial purple, and green for the ornamental borders, with the effect of emeralds.

Marble intarsia enjoyed its most flourishing period in the fourth to sixth centuries, a period rich in precious techniques of all kinds, and it was revived in Constantinople during the tenth century as a conscious recapturing of the luxury of those past centuries.

It is in the nature of the technique that the artistic effect is two-dimensional and thus dematerialized, intensified by the engraved design of the face. A flat, uncorporeal style had dominated the period just before, during, and immediately after Iconoclasm (Plate 9), preceding the revival of relief sculpture in the Macedonian Renaissance. There are already among the Fenari Isa finds a few inlaid fragments in low relief.

PLATE 11

Berlin, Ivory with the Forty Martyrs of Sebaste

One of the most popular martyrdom scenes in the Orthodox Church is that of the Forty Martyrs of Sebaste (celebrated on March 9), who were put to death by exposure in icy water. In this representation the slender but well-muscled bodies of the martyrs, old and young, are rendered in writhing poses suggesting their agony and suffering. The ivory belongs to a tenth-century Constantinopolitan group which was termed the "painterly group" because it was derived from painted models. To this group also belong a large number of caskets called "rosette caskets" from their ornament; they are decorated primarily with scenes and figures from classical mythology and provide one of the chief evidences for the so-called Macedonian Renaissance. From the same mythological models the carver of the Forty Martyrs plaque drew his inspiration, and for several of the writhing poses one finds the closest analogy among figures of the classical giants of a gigantomachy while, at the same time, their muscularity has been transformed into more ascetic proportions. One group, off center to the left, with an older man tenderly embracing a youth, may well have been inspired by a group of Pan and Daphnis. The architecture at the right is the bathhouse in which one of the martyrs tried to escape his fate, while the upper zone is occupied by Christ enthroned in a mandorla worshiped by angels, a group clearly inspired by an Ascension theme.

There is a very close parallel to this plaque in the center of a triptych in the Hermitage in Leningrad, the inner sides of whose wings are occupied by standing soldier saints in two rows. Apparently the Berlin plaque also originally formed the center of a triptych whose wings have been lost. A few traces of gold on the throne, the nimbus, and the angels' wings hint at the original splendor of this most delicately carved ivory.

PLATE 12

Utrecht, Ivory with Standing Virgin

The most venerated icon in Constantinople was one of the Virgin, called the *Hodegetria* after the Monastery of the Hodegon where it was kept (among several places in the Capital). This was the palladium of the city, carried in processions and in battle; according to tradition it was painted by Saint Luke himself and sent from Jerusalem to Constantinople by the Empress Eudocia (Plate 10). The original, lost in the sack of Constantinople in 1453, depicted a standing Virgin holding the Christ Child in her left arm. The best copies we have are a series of tenth-century ivories, and of these, the greatest masterpiece is the one now in the Archepiscopal Museum in Utrecht. It was produced in a workshop employed by the imperial court—a workshop which was responsible for several ivories with imperial portraits, such as those of Constantine Porphyrogenetos and Romanus II, after whom the group has been named the Romanos group.

The slender Virgin is carved in a style combining nobility with the utmost precision of form. It dates from around the middle of the tenth century, when Byzantine art had reached its peak during its second golden age. Corporeality is more suggested than realized in this flat relief, which, despite its small physical scale, has true monumentality. The panel strikes a perfect balance between classical form and a dematerializing concept whereby the Child does not sit firmly on the Virgin's arm, but seems suspended and thus weightless.

The plaque was the center of a triptych that, judging from other triptychs of this group, most likely had a standing saint on each wing, possibly with the bust of an angel above.

PLATE 13

FIESOLE, STEATITE WITH ARCHANGEL GABRIEL

The archangel, inscribed Gabriel, is dressed in a richly embroidered imperial *loros,* holding a staff, the imperial *labarum,* in his left hand and a disc with the head of Christ Immanuel in his right. In Early Christian art, archangels always held the globe, but after Iconoclasm the globe was sometimes replaced by an icon of Christ in the form of a *clipeus* (Figure I and Figure A). Such winged figures holding discs may well have been inspired by a classical *Victory* holding a shield.

Although standing frontally and in a stiff pose, the figure is turned slightly to the left, suggesting that it is not self-contained, but taken from a larger context, in this case an assembly of the archangels, the so-called *Synaxis*—a feast celebrated in the Orthodox Church on November 8—in which they hold the Christ medallion as an expression of subservience.

The smooth creamy steatite comes very close in general effect to ivory, for which it served as a substitute at a time when ivory had apparently become expensive and rare. The color of the steatite is somewhat different, however, usually being more olive in tone, and it is not as sturdy as ivory, cracking more easily. What makes the Fiesole plaque so attractive is the excellent preservation of the old frame and the gilding of certain parts, like the *loros,* the angel's wings, and the richly decorated nimbus. Although most ivories have had their gold rubbed off and lost, they must have resembled in this respect the steatite with the Archangel Gabriel (which belongs to the eleventh or twelfth century) and the marble icon (Figure A), which is also derived from an ivory model.

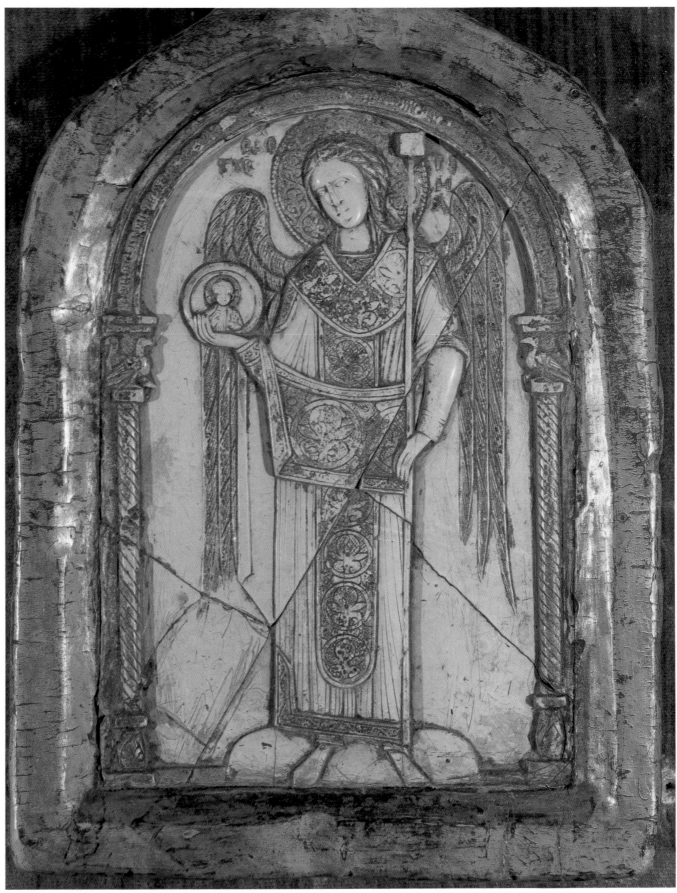

PLATE 14

VENICE, GOLD, GILDED SILVER AND ENAMEL ICON WITH BUST OF SAINT MICHAEL

Among the treasures of Constantinople looted by the Venetians in 1204 and deposited in the treasury of San Marco, perhaps the most precious piece is this icon from the second half of the tenth century with the bust of Saint Michael. Here, a variety of the most precious materials and techniques have been combined to create an impression of dazzling splendor. The head, the hands—one open and the other holding a gold *labarum* with a red stone—and the sleeves of the tunic are embossed gilded silver, its surface reflection bringing out most effectively the ethereal qualities of an angel. Special emphasis is placed upon the elaborate imperial *loros* with red and green glass and precious stones set against the finest filigree—a filigree used also for the nimbus and the background. For the garment—the dalmatic under the *loros*—cloisonné enamel of a violet color, instead of purple, is used; multicolored enamels decorate the wings, the border of the nimbus, and the frame. Moreover, in the upper corners are two medallions inscribed "Michael" and two with busts of Christ and Saint Simeon, their bicolored garments typical of the best tenth-century Byzantine *cloisonné* enamel work.

The bust of Saint Michael is the central panel of a larger icon to which were added top and bottom strips with three enamel busts each, and a larger outer frame with fourteen more busts of saints, all from more or less the same period, but reset at a later time in a typical thirteenth-century Western filigree. The later remounting affected the two medallions in the otherwise intact central plaque: Christ and Saint Simeon do not form a pair, and most likely Saint Simeon occupies a place once filled by the bust of the Virgin, which is now the second medallion in the lower frame. This and another icon with a standing Saint Michael from the early eleventh century, likewise from the Constantinopolitan loot and now in San Marco, are the only such icons with gilded silver, enamel, and stones left to give us a glimpse of Constantinopolitan art at the height of the Macedonian Dynasty.

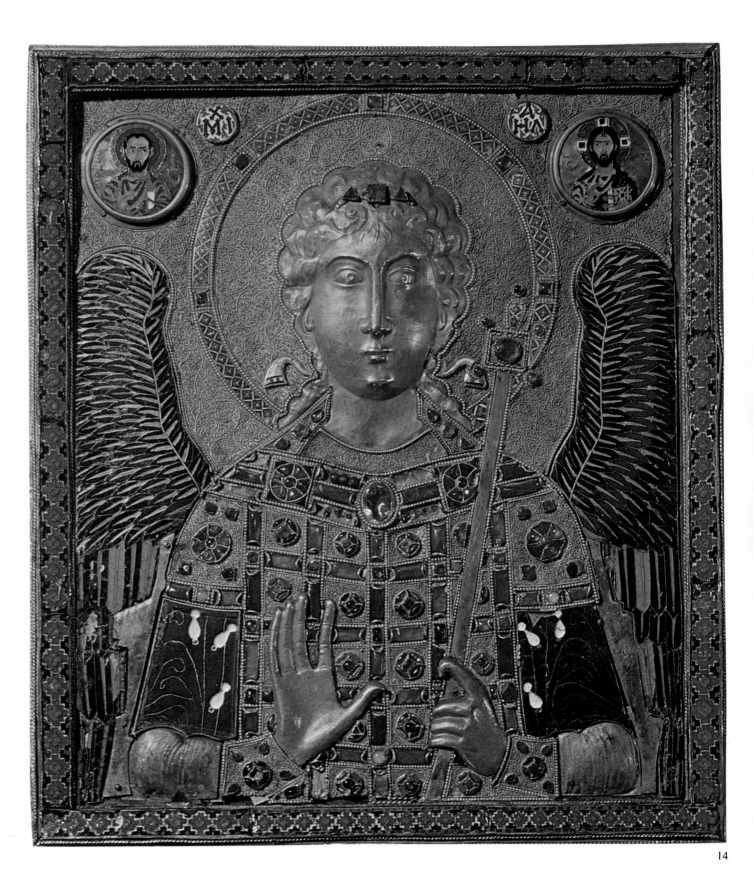

PLATE 15

BERLIN, ENAMEL WITH SAINT DEMETRIUS

The youthful Saint Demetrius, patron saint of the city of Thessalonike, is represented frontally in the pose of an Orant. Like the soldier Saints Theodore and George in the early Sinai icon (Plate 2), he is dressed in the splendid garb of a court official—an embroidered tunic and a chlamys with an inserted square, the so-called *tablion.* For a work from the eleventh century, to which this enamel must be ascribed, it is rather old-fashioned, because from the Middle Byzantine period on this Saint is usually rendered in military armor, like Saints Theodore and George (Plates 9, 34, 35).

The beauty of the *cloisonné* enamel lies in its decorative pattern with contrasting colors, some translucent, like the pinkish flesh color, the deep sea green of the chlamys, and the cobalt blue of the tunic, and some opaque, like the sealing wax red of the hearts on the chlamys, the gold-imitating yellow of the *tablion,* and the turquoise blue of the nimbus. The artist's aim was either to divide the surface into small cells like the heart decorations, or to enliven a plain color surface like the tunic by gold wires in crisscrossing or herringbone lines. By such means he stressed the two-dimensionality typical of the enamel which fills a sunken shallow area in the gold sheet, not unlike the marble intarsia in Plate 10. With this piece it also shares the effect of suspension, since the footstool, like the legs in the marble intarsia, does not rest on the ground line.

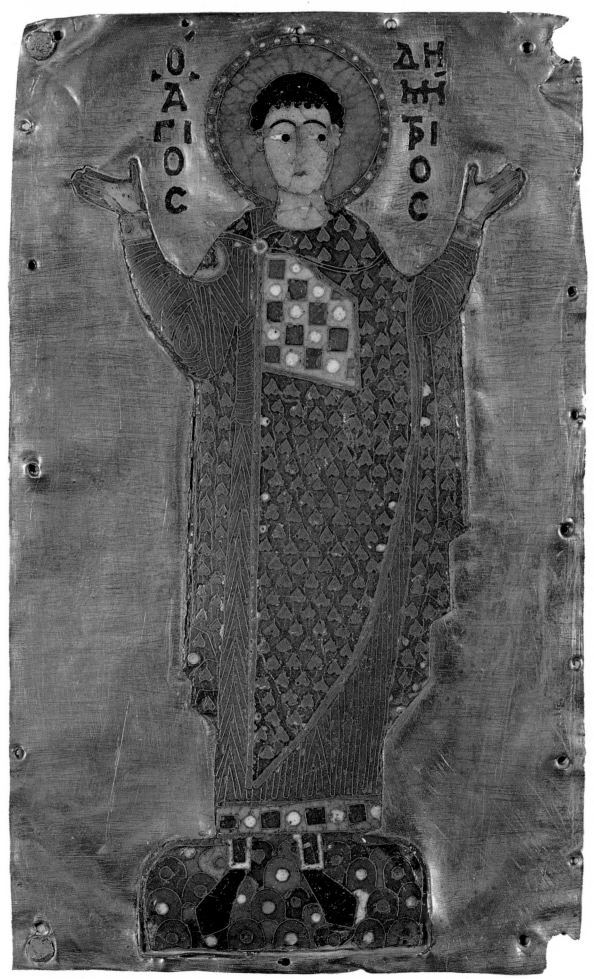

Ο ΑΓΙΟC ΔΗΜΗΤΡΙΟC

15

PLATE 16

Munich, Enamel with the Crucifixion

In contrast to the almost canonical rendering of the Crucifixion from the Middle Byzantine period onward, which is confined to the Crucifixus, the Virgin, and Saint John (Figure C and Plates 26, 38), this twelfth-century enamel in the Reiche Kapelle in Munich follows an older, narrative tradition. The Virgin is followed by another Mary, and Saint John by the centurion; below, the three soldiers cast lots for Christ's garment, and four angels instead of the usual two hover above the Cross.

The employment of a multifigured composition is obviously due to an enamel artist's desire to break up large expanses of gold ground, indicating *horror vacui*. Even the framed inscription panels (reading vertically and horizontally in Greek): Crucifixion; Behold thy son, Behold thy mother (John 19: 26–27), are carefully placed space fillers, as are some of the weapons of the three soldiers, and the vessel in which Christ's blood is collected—a rare feature in Byzantine art. And, rather than being held, this vessel is suspended. As in the icon with Saint Demetrius (Plate 15), wherever he could the artist broke up the surface of the figures into the smallest possible cells, for which the armor and leggings of the soldiers, their shields, and even the tiny flower-covered hillock of Golgotha with the skull of Adam, provided him a welcome opportunity.

It is hardly by chance that another multifigured Crucifixion, originally decorating an iconostasis beam, is found among the contemporaneous enamels of the Pala d'Oro in San Marco in Venice, where it is part of the cycle of the twelve great feasts. This suggests that the Munich plaque also may originally have been part of a set of twelve feast icons, although it is more likely from a set of individual panels than from an iconostasis beam.

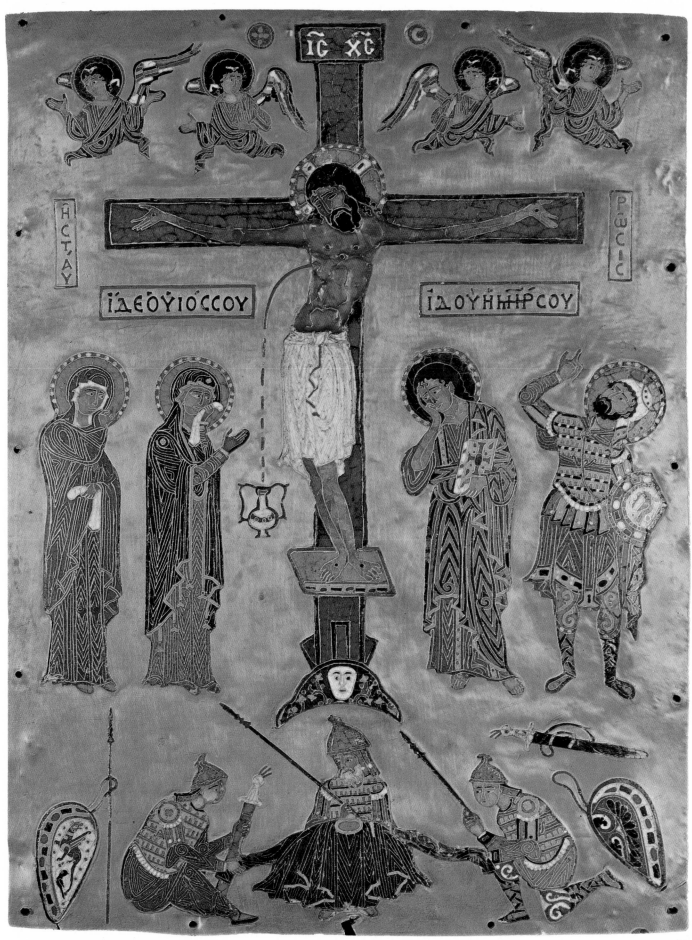

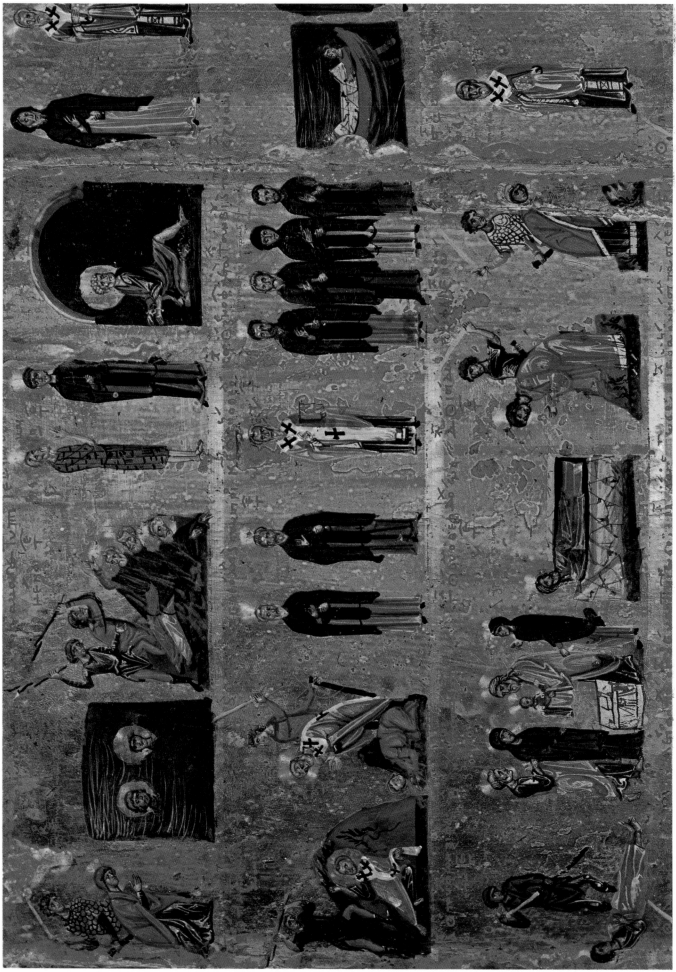

PLATE 17

SINAI, CALENDAR ICON (DETAIL)

Sinai possesses the oldest extant calendar icons, which reach back almost to the time of their invention at the end of the tenth or the early eleventh century under the influence of the compilation of all the Lives of Saints by Symeon Metaphrastes. The section reproduced here is from one of four panels, each covering three months in three strips. This detail begins with January 12 and ends with February 27, omitting the days which were on a narrow strip missing at the right. Each single day of the month has, neatly parceled, either a frontal standing saint or a scene from his life, effectively set against a gold ground, with an inscription giving the day of the month, the name of the saint, and in many cases indicating the nature of his martyrdom. These inscriptions are translated into Georgian, apparently for the colony of Georgian monks which at that time lived at Sinai (Plate 9).

Most martyrs were put to the sword (Saint Tatiana, first at the upper left), others beaten to death (Saint Timothy, first in the second row), yet others drowned (Saint Hermylos and Saint Stratonikos, second in first row) or burned (Saint Theodore Teron, last in the fourth row). The Constantinopolitan character of the calendar is stressed by the depiction of Saint Peter in Prison (fifth in the first row), bringing to mind his chains which the Empress Eudocia had brought to the Capital (Plate 10); the transfer of the relics of Saint John Chrysostom (sixth in the second row), and the finding of the head of Saint John the Baptist, one of the greatest relics in Constantinople (fifth in the fifth row).

These scenes, as well as the standing saints, agree thoroughly in style and iconography with the corresponding miniatures in *menologia,* and there can hardly be any doubt that this is not merely a dependence of one upon the other, but that such icons were actually painted by artists who were primarily miniaturists. The frail and ascetic figure style not only fits the calendar scenes, but is typical of the second half of the eleventh century, to which this panel must be ascribed.

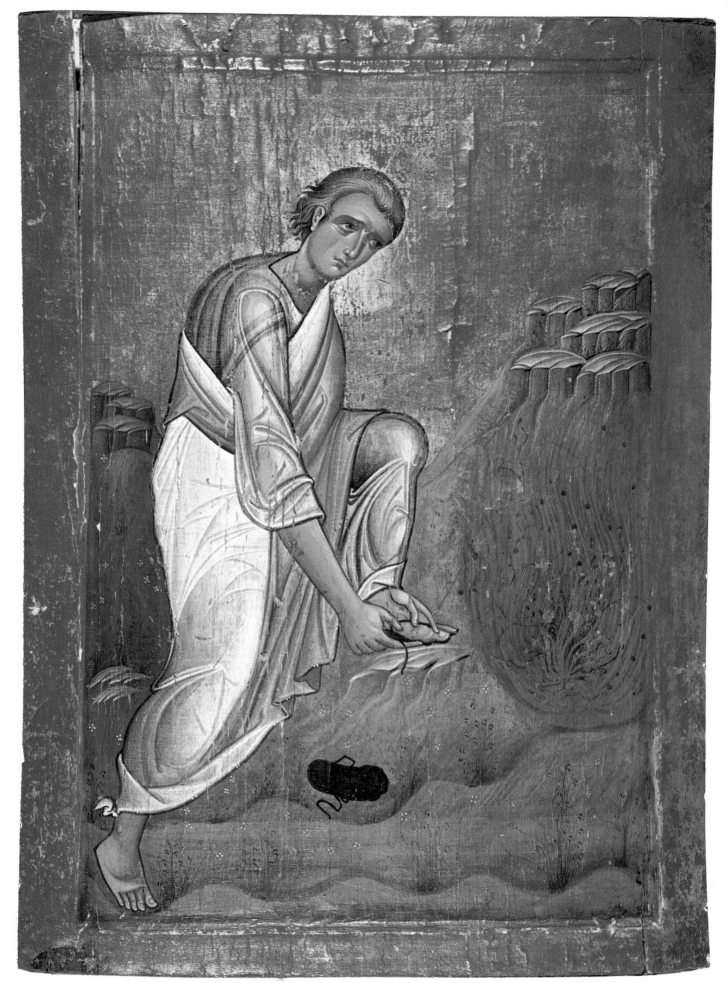

18

PLATE 18

SINAI, ICON WITH MOSES BEFORE THE BURNING BUSH

The *loca sancta* pictures of Sinai properly emphasize the Burning Bush on the site of which, according to tradition, the Monastery was built. They are of two different types, both very frequently represented: a depiction of the narrative showing Moses loosening his sandals (Exodus 3:2), and a symbolic rendering of the vision of the Virgin in the Burning Bush — a version which, strangely enough, in its earliest examples does not show the bush behind the Virgin (Plate 30).

The stately icon reproduced here, with Moses at Mount Horeb, is located in a side chapel close to the entry of the Chapel of the Burning Bush, and may well originally have been in this chapel as the chief picture of this event. It shows a youthful Moses, as is typical of this phase of Byzantine art (the icon belongs to the twelfth or perhaps to the thirteenth century), placing his left foot on a rock in order to loosen his sandal more conveniently. He wears a light blue tunic and a mantle which changes in color from red to white and has some bluish shadows. The composition is well thought out: the mountain with the large fire that almost consumes the bush balances the figure of Moses, and the strong diagonal formed by the seam of the mantle and by the slope of the mountain gives a lively accent. A tiny prostrate donor figure in the lower left corner of the frame was probably an afterthought. This icon may well have been executed on-the-spot in the Monastery by a painter who, if not a Constantinopolitan himself, was surely influenced by the art of the Capital.

PLATE 19

SINAI, ICONOSTASIS BEAM. DETAIL WITH RAISING OF LAZARUS

This scene is from one of the earliest known of several iconostasis beams which have as their subject the cycle of the twelve great feasts of the Orthodox Church. The scenes are distributed over four wooden boards—each with three feasts—which are now separated in different places in the monastery. The Raising of Lazarus shows Christ followed by only two disciples, one recognizable as Saint Peter, while before him, Lazarus's two sisters are rendered in *proskynesis* in smaller scale. Two servants are carrying away the stone that had sealed the tomb, while a third unwinds the mummy's shroud and at the same time holds one hand before his face, just like the first stone carrier, trying to protect himself against the stench of the corpse (John 11:39). The scene is placed under an arch with an enamel pattern, reminding us that there did indeed exist, as in the upper part of the Pala d'Oro in San Marco in Venice, iconostasis beams executed in that luxurious technique.

The figures are rather flat with straight outlines, thereby achieving an effect of monumentality. In these respects and some additional details—like the vertical grooves in the foreheads, the craned neck of Christ, and the decorative concentric fold lines over the shoulders—the figures resemble those of frescoes in Cyprus, especially those of the Church of Asinou dated 1105–1106, suggesting also for this iconostasis beam a date in the first half of the twelfth century and execution by a Cypriot artist, either in Cyprus proper or at Sinai where artists from Cyprus were quite at home, since Sinai still owns estates, so-called *metochia,* on that island. Quite different from what we know of contemporary Constantinopolitan icons those from Cyprus not only display comparatively more abstract figure types, but also light, almost pastel colors.

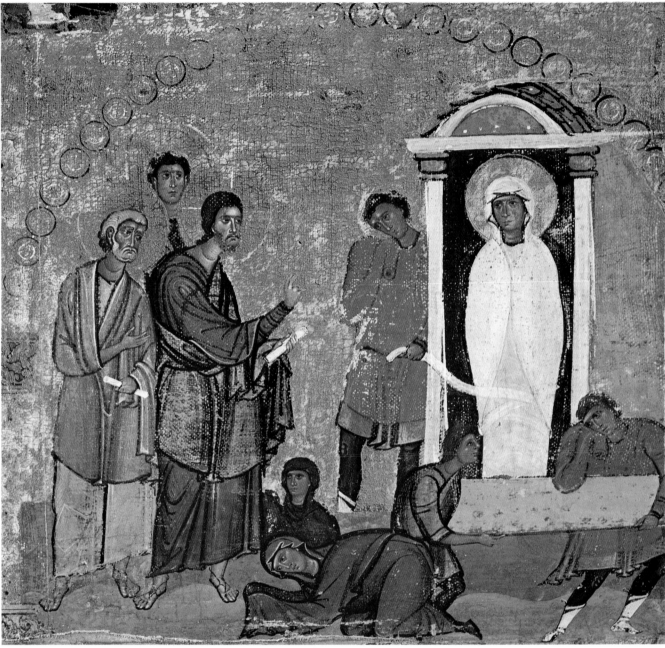

19

PLATE 20

Sinai, Iconostasis Beam. Detail with Miracle of Saint Eustratios

It is not unique, but certainly a very rare case where an iconostasis beam will have, instead of the twelve great feasts, scenes from a saint's life. In the present case they represent miracles performed by Saint Eustratios, chief among the five Martyrs of Sebaste who are commemorated on December 13. This beam was made for a chapel within the walls of Saint Catherine's Monastery dedicated to them, although it is no longer in its original location. Distributed over two boards are eleven scenes, and off center to the left is the *Deësis,* which usually is at the center of the feast cycle (Figure VII).

One of the scenes depicts the Saint in an embroidered, intense red tunic and a blue chlamys (the military mantle, because he had been a soldier), healing a demoniac rendered in the same characteristic pose as the demoniac who is healed by Christ. A cleric with two followers stands at the right holding a casket containing the relics of Saint Eustratios, making it quite clear that the event takes place after the Saint's death when his presence is being invoked. This and also the other scenes, thus, do not illustrate the Life of Saint Eustratios as we know it from Symeon Metaphrastes, but an otherwise unknown text of the miracles of the Saint.

The scenes are not only placed under enamel-patterned arches similar to those in the previous beam (Plate 19), but the style is so close that in this case we are also viewing a product of the same Cypriot workshop during the first half of the twelfth century, although it was done by another master, who was slightly less accomplished in design but used more saturated colors.

PLATE 21

Moscow, The Virgin of Vladimir

The holiest icon of Russia, the palladium first of the city of Vladimir and then of Moscow, is not a Russian but a Byzantine icon, painted in Constantinople around 1131, the year it was brought to Russia. When soon after its arrival in Russia it was covered by a silver *oklad,* the surface suffered damage and it has been repeatedly restored. As revealed by the restoration, only the faces of the Virgin and the Christ Child and a small patch below his neck are original.

The Virgin holds the Child in her right arm and points at him with her left hand, while the Child puts his left arm around the Virgin's neck and presses his cheek against hers. This is the type known in Greek as *Eleousa* and in Russian as *Umileniye* (the merciful or compassionate). Although the gestures indicate a close relationship, the Virgin's face does not so much express maternal affection as it does—if any term of human emotion can be applied—slight melancholy, as if she were foreseeing the Passion of her son, prefiguring in this respect a later, related icon type in which the implements of Christ's Passion were added. The almond-shaped eyes, the narrow, elegantly drawn nose, the dark olive green shadows in the face—all these features have a dematerializing effect, stressing the Divine. A touch of worldly reality can be seen in the smooth treatment of the flesh, revealing the ever-present heritage of the classical tradition in Constantinopolitan art, of which the Virgin of Vladimir is the most outstanding Comnenian work we have today.

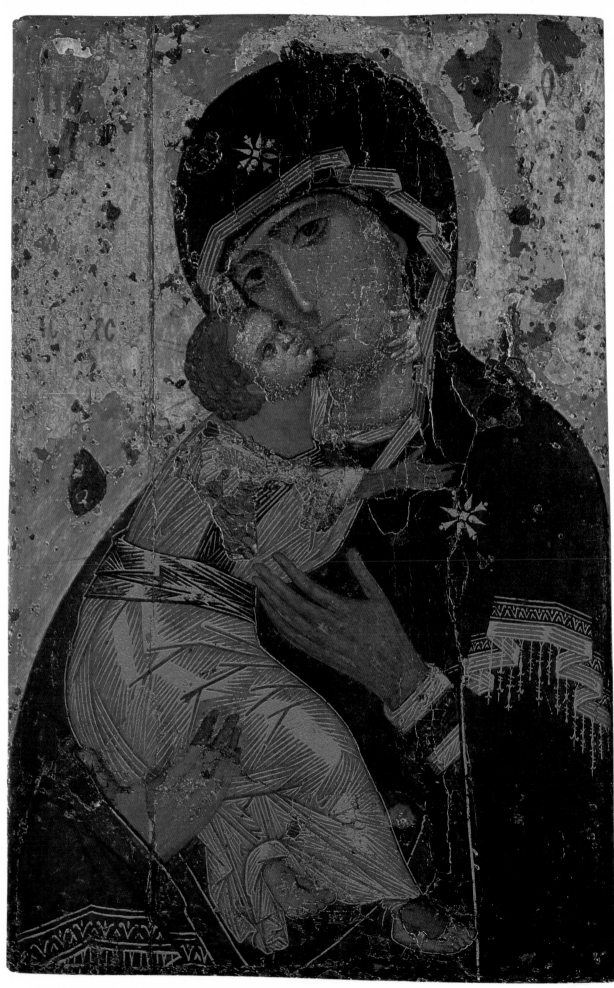

PLATE 22

Sinai, Icon with Miracle of Saint Michael

On Saint Michael's day, September 6, the Orthodox Church celebrates the archangel's miracle at Chone. The devil had tried to sweep away the hut of the pious, unyielding monk Archippus, but Michael intervened, diverting the river and saving the hut.

In this icon the frail, slender monk, with a spiritual face and clad in somber-colored brownish garb, stands before a building adorned with precious marble rather than a simple hut, and he faces his savior, who is in every respect contrasted to the monk. Rendered on a superhuman scale, the angel advances with a gracious movement and dips his cross staff into a pool which collects two streams of water flowing down from two hills forming arches, creating a balanced composition. Emphasizing bodily values under the rhythmically flowing garments of light blue and light yellow, the angel's figure, with its face of Apollonian beauty, has a classical appearance which distinguishes him from the much more ethereal archangels in representations of their *synaxis* (Plate 13). The difference may be explained by the fact that in the *synaxis* the angels appear in heaven, while in the Chone miracle Michael performs a heroic task on earth. Adding to the spiritual quality of both figures is the peculiar effect of the gold nimbus which is treated to give the impression of rotation.

The elegance of the design, the refinement of the colors, and the sensitivity of the faces suggest that this icon was produced in a Constantinopolitan workshop dating in the first half of the twelfth century.

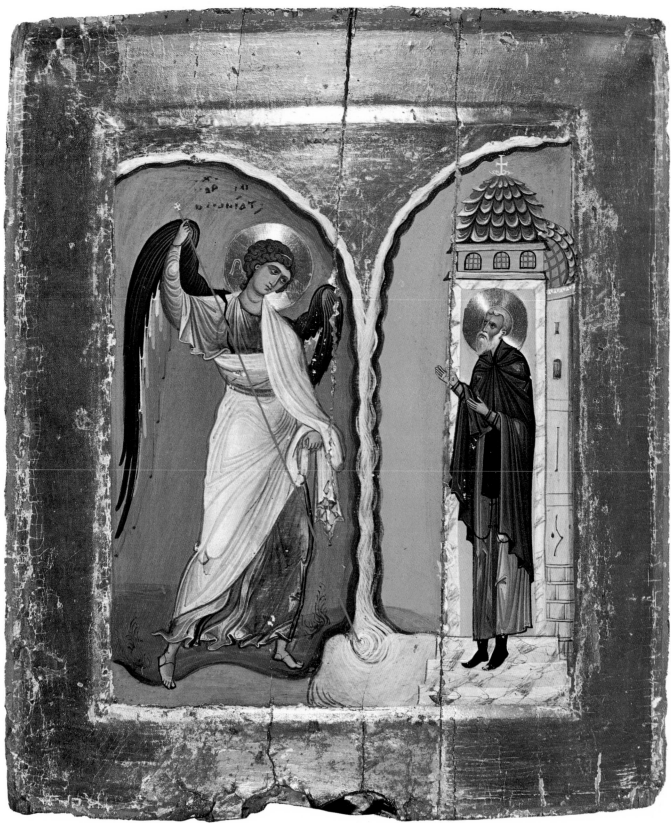

22

PLATE 23

SINAI, ICON WITH THE LAST JUDGMENT

In Constantinople during the tenth or eleventh century there apparently was invented—presumably to decorate the west wall, that is, the sunset side, of a church—a monumental and complex Last Judgment composition. In a comparable setting this composition was copied in mosaic in the Church of Torcello near Venice, and in reduced form in icon and miniature paintings. All copies show slight variations but are so similar in their basic layout that a common archetype must be assumed.

The Sinai icon shows Christ in gold garments flanked by the Virgin and Saint John the Baptist (the *Deësis*), and the twelve Apostles seated like judges on chairs above a curved ground line suggesting heaven; the choir of angels stands guard behind. Underneath, separated from each other by the *hetoimasia*, the prepared throne (Matthew 19:28; 25:30), the elect, neatly compartmentalized in groups (Apostles, Prophets, martyrs, bishops, monks, and women) stand on Christ's right side, along with the Virgin, the good thief, and Abraham with the souls in his bosom, while on His left side we see the condemned who are exposed to all kinds of tortures. Some are consumed by fire emanating from heaven, bypassing the angel who unfurls the scroll of heaven with sun, moon, and stars.

The panel is the right wing of a pair, whose left wing contains the cycle of the twelve great feasts. Into these wings fit outer wings, depicting at the top the Birth of the Virgin and her Entry into the Temple—two great feasts supplementary to the canonical twelve—and below two rows of saints in the proper order of rank. In this way the tetraptych comprises a full liturgical program.

The delicate figure style in brilliant enamel-like colors is very close to Constantinopolitan miniature painting from the middle of the twelfth century, and it is quite possible that this artist was also a miniature painter (Plate 17).

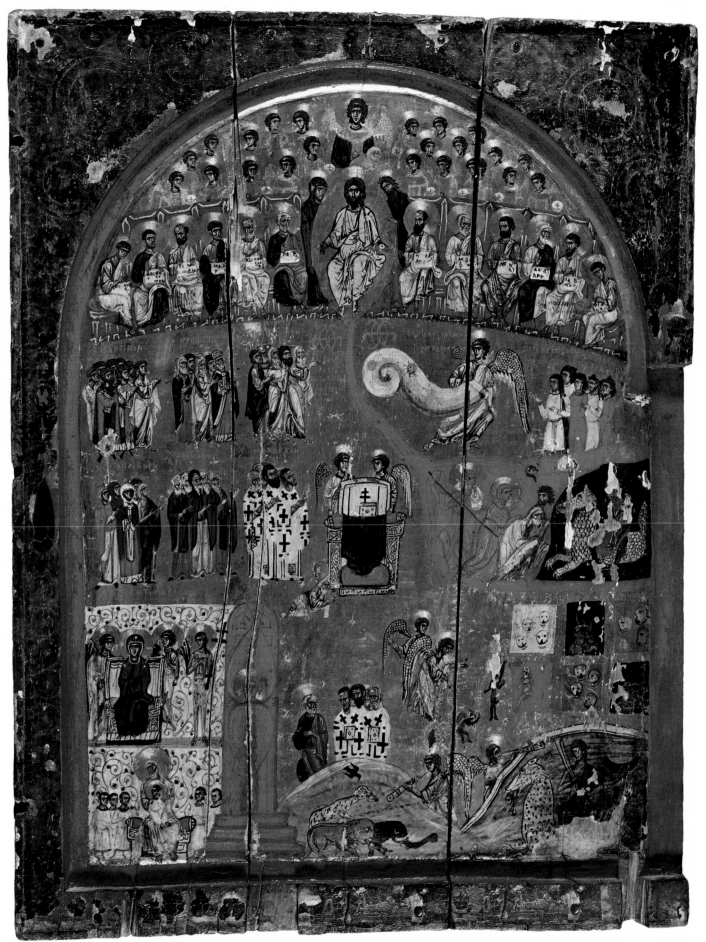

PLATE 24

SINAI, ICONOSTASIS BEAM. DETAIL WITH TRANSFIGURATION

The Transfiguration of Christ (called the *Metamorphosis* in Greek) owes its importance within the feast cycle to the fact that it demonstrates vividly the dogma of the two natures of Christ which plays such a great role in the Orthodox Church. What could be a better demonstration than to show Christ before the eyes of his disciples changing from human into divine and back into human nature.

Christ stands in a mandorla flanked by the youthful Moses holding the tablets of the Law and by the elderly Elijah, while the three disciples kneel on the ground, Saint Peter at the left pointing at Christ, Saint James at the right turning his head around while he tries to rise from the ground, and Saint John in the center trying to cover his eyes with his mantle. These three Apostles vary somewhat from the more usual types depicted in the mosaic icon of the same subject (Plate 28).

The subject lends itself to a balanced symmetrical composition of great hieratic quality. At the same time, the first signs of emotion and restlessness begin to pervade the figures, foreshadowing the late Comnenian style (Plate 28) and dating this beam, most likely the work of a Constantinopolitan painter, around the middle of the twelfth century. Christ is given a slightly contrappostic pose, Moses cranes his neck, and he and Elijah show strain in their faces, while the disciples display physical reactions to the strong light of Mount Tabor. The roughening of the gold mandorla, the nimbi, the arches and discs in the spandrels all contribute to the impression of intense light.

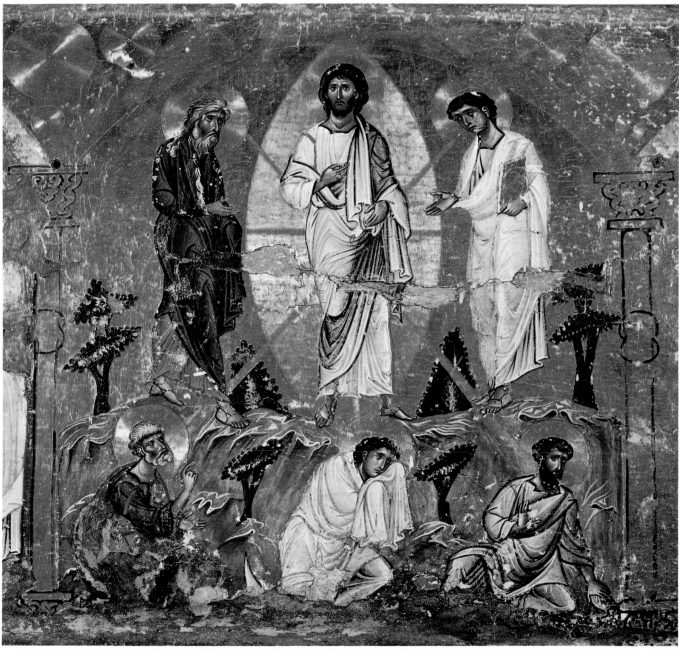

24

PLATE 25

SINAI, ICON WITH THE HEAVENLY LADDER

A treatise from the end of the sixth century by Saint John Climacus, Abbot of Sinai, written for the edification of monks, deals with the virtues and avoidable vices in thirty chapters, symbolized in the thirty rungs of the ladder a monk must climb to reach heaven. From about the eleventh century onward we repeatedly find frontispieces in manuscripts with monks climbing and falling from a ladder, and from such a miniature this icon has been derived. Devils interfere to impede the ascent of some monks, dragging them down into the open mouth of Hell. The monk who has succeeded in avoiding all pitfalls, being welcomed by Christ in heaven, is none other than Saint John Climacus himself, and he is being closely followed by an oversized bishop, inscribed "Antonios," apparently a Bishop of Sinai at the time the icon was made, and who may well have been the donor of this icon.

The artist has dressed the eager monks in garments of subtle, subdued colors contrasting with the gay, light colors of the tunics and mantles of the host of angels who are prepared to receive the victorious monks. The expressiveness of the faces is achieved more by linear means than by the painterly means employed in the two preceding icons. It must be left undecided whether our icon was made by a Constantinopolitan artist. The inclusion of Bishop Antonios in this particular copy may indicate that it was made at Saint Catherine's by a visiting monk from the Capital. Artistically it was very daring to restrict the painted area so severely on a vast surface of gold, but this has placed all the more emphasis on the silhouette effect of the rhythmically ascending and falling monks and the sinister little devils.

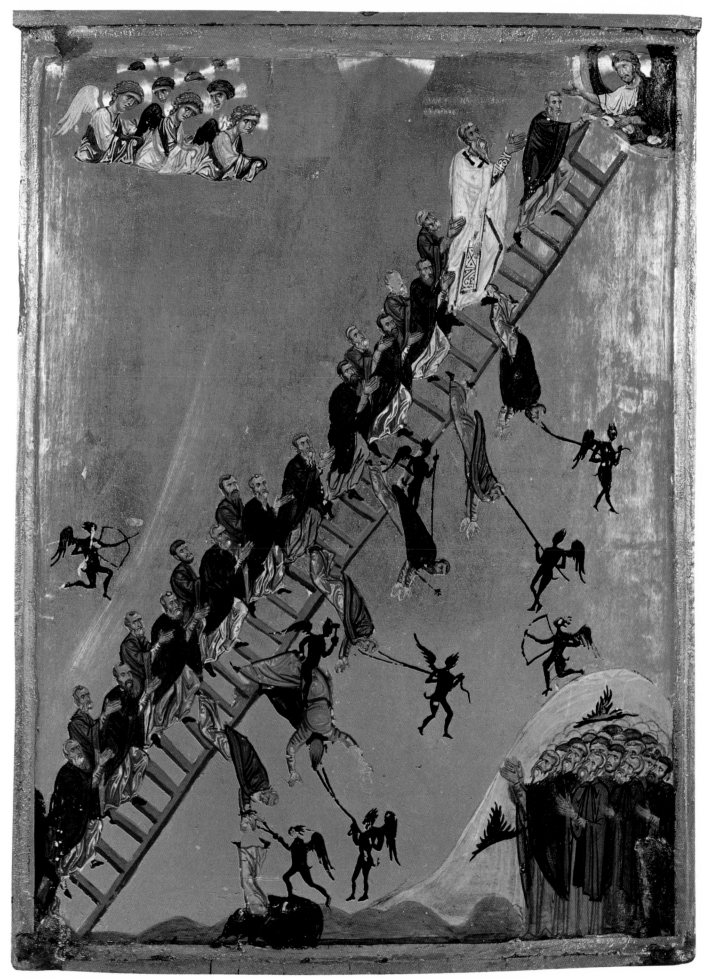

PLATE 26

Sinai, Icon with the Crucifixion

While the basic concept of the Crucifixion as a feast picture—its confinement to Christ, the Virgin, and Saint John—has been preserved in this panel in contrast to the narrative concept (Plate 16), subtle changes have taken place in accordance with the trend of the time to emotionalize the climactic event of the Passion. Instead of standing straight on the *suppedaneum* (Figure C), Christ's body, draped in a transparent loincloth, sags, and his head with eyes closed falls on his shoulders, while blood streams profusely from his five wounds. The Virgin, instead of making a worshipping gesture, crosses her arms, and Saint John, instead of holding a codex and pointing at Christ, inclines his head and rests his right hand in a mournful gesture against his cheek.

All these details are rendered in the refined and slightly mannered style of Constantinople in the late Comnenian period (second half of the twelfth century). The figures have over-elongated proportions. In the case of Christ, this results in swinging curves, creating an ambiguity concerning whether he is dead or still alive; the folds of the Virgin's somber deep blue and purple garments fall straight and thus have a dematerializing effect; and, in contrast, the crowded, crumpled folds over Saint John's left arm express an inner restlessness. All three faces are strained, each in a different and appropriate way.

The frame is filled with medallions of saints in the liturgical order of rank. At the top, Saint John the Baptist is flanked by the archangels Michael and Gabriel, and they are flanked in turn by Saint Peter and Saint Paul. On the sides there follow in pairs first the Church Fathers Saint Basil and Saint John Chrysostom, Saint Nicholas and Saint Gregory of Nazianzus, then the soldier Saints George and Theodore, Demetrius and Procopius, and at the bottom two Stylite Saints, the younger and the elder Symeon, the monk Barlaam, and the female Saints Catherine and Christina. The placement of Saint Catherine in the center may well indicate that the icon was made for Sinai.

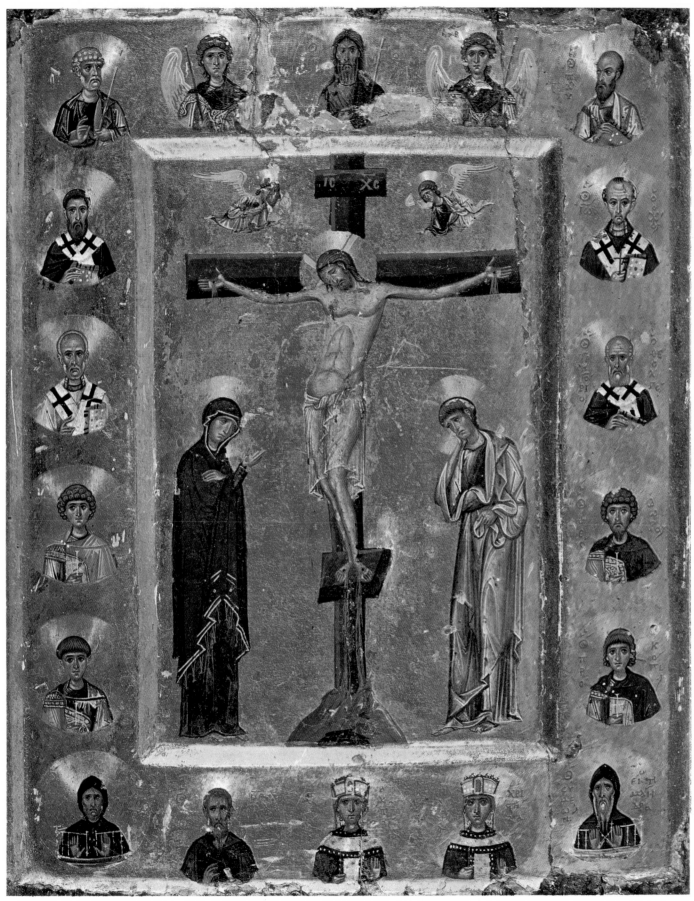

PLATE 27

SINAI, ICON WITH ANNUNCIATION

The latest phase of Comnenian art is represented by a rather unique masterpiece, depicting the Annunciation, striking for its high emotional quality as well as its refined and unusual technique. The slender Virgin, not the stately matron of the past, but a frail woman, looks tense and apprehensive as she is diverted from her spinning, while the equally tense, approaching angel, in an almost recoiling movement, looks inquisitively into the sad face of the Virgin, anticipating her sorrows. The serpentine movement of the angel, which has its ultimate roots in a dancing maenad of classical antiquity, and the agitation of his mannered drapery underscore the scene's high emotional pitch. The dove of the Holy Spirit in a golden medallion descends upon the Virgin, and a seated Christ in a mandorla is indicated on the upper part of her body in the most delicate fleeting design. At the bottom of the panel, a broad stream with fish and waterfowl illustrates one of the Virgin's epithets as found in hymns—"a grace-giving stream."

Colors are sparingly used and confined to deeply saturated blue and purple for the Virgin's garments and the tips of the angel's wings, red for the cushion and the wool, and blue for the water. The rest is done in gold *grisaille* which as striation enlivens the angel's garments and imparts an exuberant richness to the jewel-studded throne and the architecture with the roof garden. Once more the rotating disks contribute to a glistening effect.

There exist very similar Annunciation scenes in two frescoes, one at Kurbinovo in Yugoslavia, dated 1191, and the other at Lagoudhera on Cyprus, from 1192. They do not display the refinement of this icon, which surely is a Constantinopolitan work, but they help to date it accurately at the very end of the twelfth century.

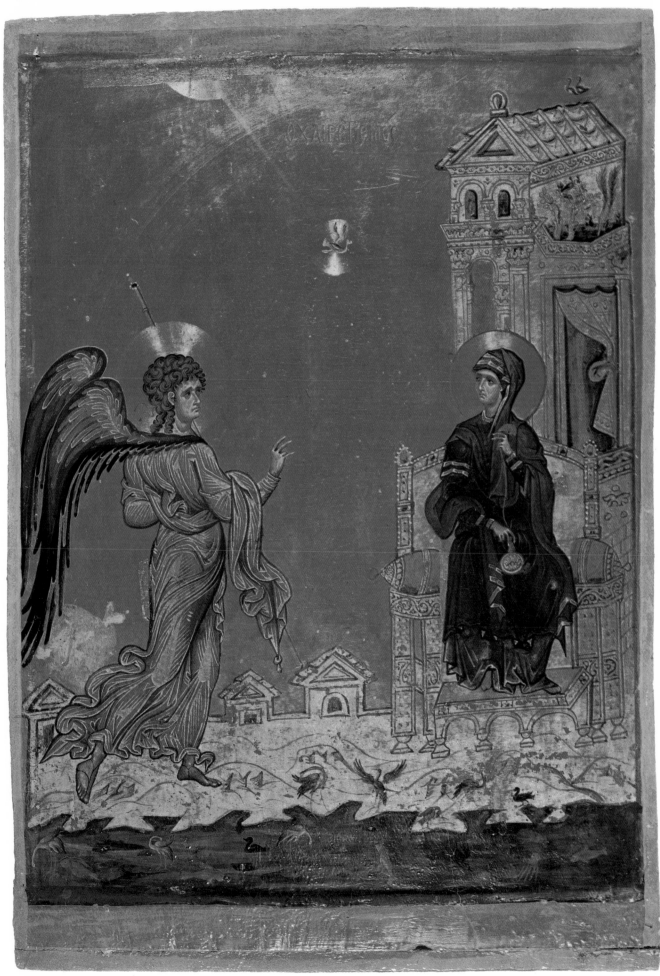

27

PLATE 28

PARIS, MOSAIC ICON WITH TRANSFIGURATION OF CHRIST

This representation of the Transfiguration is quite closely related to that in the iconostasis beam of about half a century earlier (Plate 24), especially where the figures of Christ and the flanking Prophets Moses and Elijah are concerned; it differs, however, in the depiction of the disciples. In this respect the mosaic icon follows closely the lost wall mosaic in the Church of the Holy Apostles of Constantinople of which Nicolaos Mesarites, a twelfth-century writer, has this to say in his *ekphrasis:* "Peter [lower left], the most vehement, springing up from the ground. . . . James [right], partly rising with difficulty on his knee . . . still has the greater part of his body nailed to the ground, while his right hand he holds closely to his eyes, like one who . . . is wise enough to protect his eyes with the shadow of his hand. John, however [center], does not wish to look up at all, but . . . seems to lie there in deep sleep."

In the composition, a certain tension is achieved by the use of a comparatively narrow, vertical format, whereby the figure of Christ is lifted from the ground and suspended in the mandorla. In conformity with late Comnenian style the figures are more elongated, the drapery (for example at Christ's and Saint James's left sides) flutters in agitated, linear design, and the crumpled folds of Saint John's mantle cascade onto the ground. The strained faces of the prophets show the emotionalism common at this time, while the rather sad, almost melancholy faces of all the saints foreshadow developments of the thirteenth century; thus we propose to date the icon at the turn of the century.

This is one of the very finest of the comparatively rare portable mosaic icons, executed with the tiniest cubes in the very subdued colors which began at this time to replace strong contrasting colors. It must have been produced in one of the most renowned mosaic workshops in the Capital.

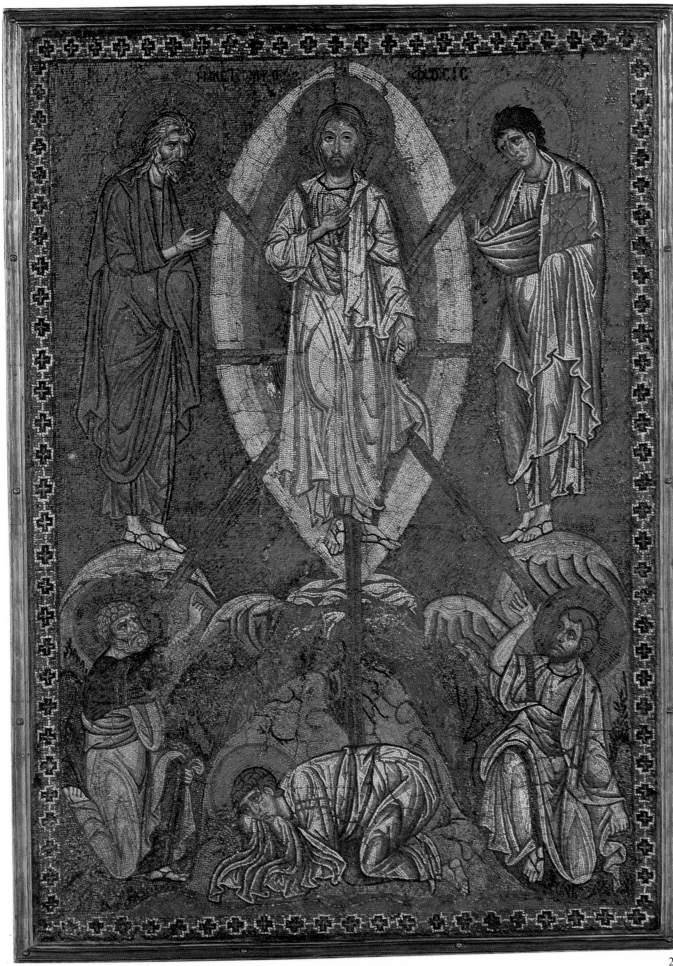

28

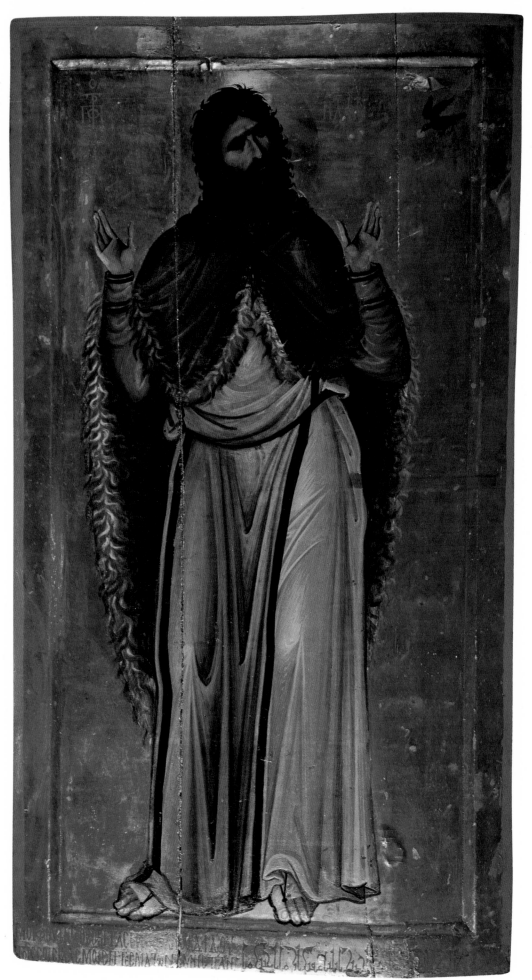

29

PLATE 29

Sinai, Icon with the Prophet Elijah

Rendered in three-quarter life size, this imposing figure of the Prophet expresses a trend toward monumentality as seen in fresco paintings of the early thirteenth century, which apparently influenced this icon. In a calm, dignified pose, Elijah raises his hands, the open palms turned slightly inward and creating free space around the figure; he looks up to heaven, whence a raven flies down with a loaf of bread to feed him (I Kings 17:6). The somber, long brown tunic and the olive-colored, fur-trimmed mantle remind one of the garments of Saint John the Baptist, the other Prophet in the wilderness (Plate 7), as does the dishevelled dark hair, while normally Elijah is represented with white hair. The strong modeling of the face, with its lively glance and deeply overshadowed eyes, reveals an exacting observation of the surrounding world, and thereby, more strongly than usual, the hand of an individual artist. This icon has an artist's signature—the earliest known to me. His name is Stephanos and the inscription, stating explicitly that he painted this picture and asking God's forgiveness of his sins, is written in large letters on the bottom frame both in Greek and Kufic Arabic.

The icon is one of a pair, its companion piece (also signed by Stephanos) depicting Moses receiving the tablets of the Law. Representative of the highest quality achieved in icon painting in this period, there can hardly be any doubt that these panels must have been executed by an artist trained in Constantinople, although they may well have been executed around 1200 in the Sinai Monastery. The iconography is typically Sinaitic, not only where the Moses scene is concerned, but because Elijah's cave is in a chapel slightly below the peak of Moses Mountain. The bilingual inscription also speaks in favor of an origin at Sinai.

PLATE 30

Sinai, Icon with Isaiah and the Virgin

The white-haired Prophet, dressed in blue tunic and ochre mantle, stands worshipping the Virgin, who, unaware of him, faces the spectator. Dressed in a blue tunic and a maphorion of brown, which must be understood as a substitute for purple, she holds the Christ Child, dressed in gold-striated brown garments, in a seated and yet suspended pose before her breast.

This type, familiar in Sinai art, is that of the "Virgin of the Burning Bush," that is, of the *locus sanctus* of the Monastery. This icon is part of a serial production, in which the Virgin is repeated without change, but confronted each time by a different worshipper. There exist ten such icons, all of the same size; the worshippers being, besides Isaiah, Moses, Joachim, Symeon, the soldier Saints George (twice) and Theodore, and the monk Sabas (twice). The saints were presumably selected as namesakes of the donors who commissioned the icons, either as votive gifts or as souvenirs. Such a production would indicate a local workshop, and this is also supported by the fact that we can recognize the same workshop in other Sinai icons, all to be dated at the very beginning of the thirteenth century, apparently a time of great artistic activity in the Monastery. The relationship to the art of the Capital is close, but whether the artist was Constantinopolitan or local is impossible to say.

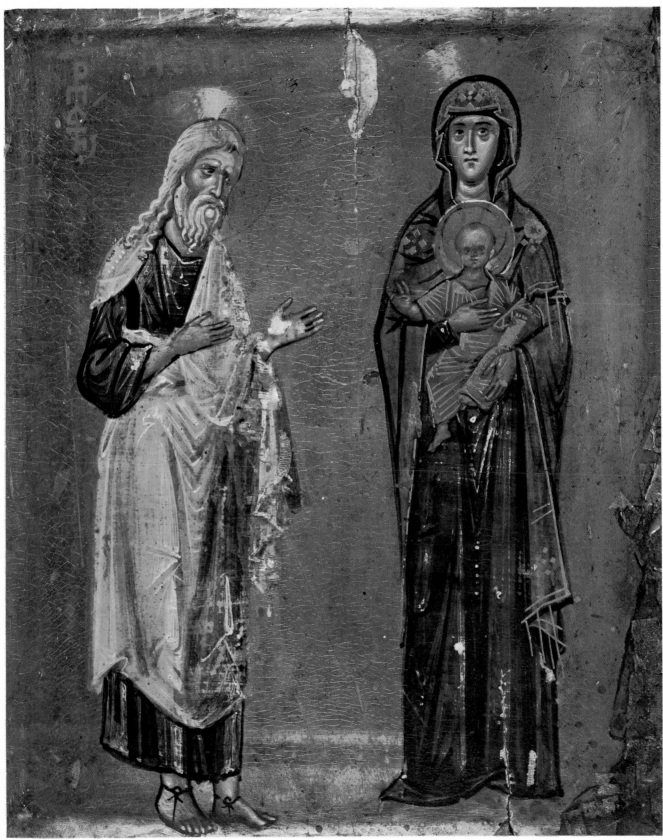

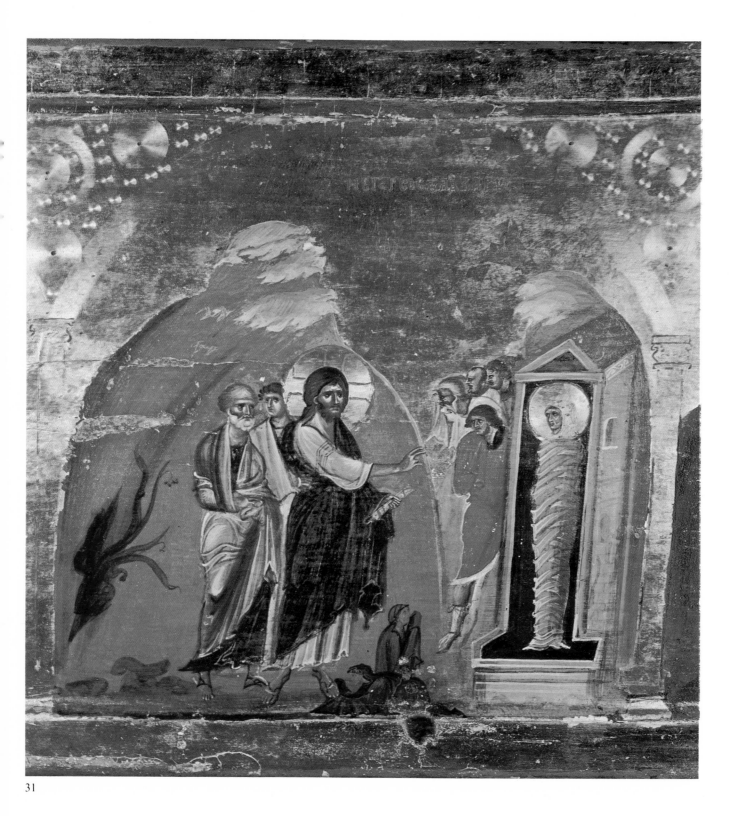

31

PLATE 31

SINAI, ICONOSTASIS BEAM. DETAIL WITH RAISING OF LAZARUS

One of the innovators of the beginning of the thirteenth century, though we do not know his name, was the painter of this iconostasis beam. Only the central of these three boards, unfortunately, has been preserved, with the *Deësis* in the center and a pair of feast pictures left and right, including this Raising of Lazarus. We can trace the hand of this artist in an earlier beam where he collaborated with artists working in the typical late Comnenian style. His aim, like theirs, was to emotionalize, but instead of using linear means as seen in crumpled fold systems, he tried to achieve a similar effect by painterly means. Rather than using contrasting colors, as was typical throughout the Middle Byzantine period, he applied a wide range of shades of a single color — here blue, from the lightest to deep ultramarine, as in Christ's mantle. Particularly stirring is the unrealistic orange of the mountain, whose peak looks like windblown snow caps. In general, the artist gave more space to the landscape elements (Plate 19), counterbalancing the usual mountain behind Lazarus's tomb with another, very prominent one embracing the group of Christ and the Apostles. In such details were foreshadowed the development of the close figure-landscape relationships typical of fourteenth century art. Iconographically as well, the painter is an individualist by, for example, giving Saint Peter, who like some of the other figures has a brooding look, wig-like hair instead of the traditional curls. Lazarus's sisters at Christ's feet are exceptionally small and *grisaille*-like in order not to detract from the main theme. This innovative painter must have lived in the Monastery and been the head of a productive atelier.

PLATE 32

SINAI, MOSAIC ICON WITH VIRGIN AND CHILD

This stately bust of the Virgin is a variant of the *Hodegetria,* whose original type is better preserved in the ivory from Utrecht (Plate 12). Contrary to the tradition, the Virgin holds the Child in her right arm, and her head is slightly more inclined than usual, introducing a more human element, perhaps under the impact of the *Eleousa* type (Plate 21), without impairing, however, the aloofness and emotional restraint that emphasize her divinity. Moreover, the Christ Child braces the scroll against his knee instead of holding it in his hand as is found in normal *Hodegetria* depictions.

Reflecting the monumental style of the early thirteenth century, the icon has been executed in the most refined mosaic technique, which since the twelfth century had become popular for portable icons in Constantinople, where this icon undoubtedly was made. Compared with wall mosaics, the icon artists worked with very minute tesserae, which are so tiny, particularly in the flesh areas, that they can hardly be discerned as such by the naked eye. The artist's intention was almost to obscure the technique by imitating the effects of the brush. In the purple *paenula* with its golden highlights, however, the lines of cubes are still discernible. Adding to the impression of preciousness, the artist covered the background with a pattern of stylized rosettes, clearly an imitation of *cloisonné* enamel, as are the medallions with the inscription and the crenellation pattern on the frame (Plate 14).

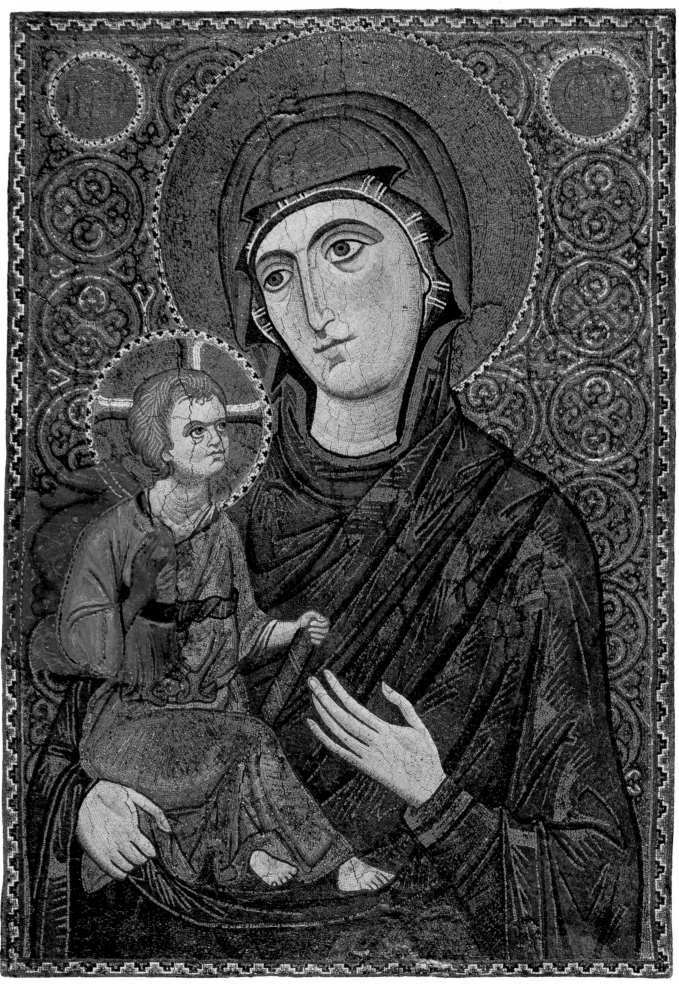

PLATE 33

SINAI, ICON WITH SAINT NICHOLAS (DETAIL)

By far the most popular of the Greek Church Fathers in Byzantine art is Saint Nicholas. While at first his rather realistic facial features varied, by the twelfth century a stylized ascetic type had developed, which became canonical for all Greek as well as Russian icon painting. Characteristic of the type are the very high forehead with stylized wrinkles, framed by a narrow wreath of white hair that continues along the sunken cheeks and ends in a rounded, parted beard. In this instance rouge on the cheeks enlivens the otherwise austere face with its penetrating eyes. Dressed as a bishop in a purple phelonian *(chasuble)* and a white omophorion *(pallium)* with golden crosses, he makes a blessing gesture and holds a jewel-studded Gospel book.

The severity of the composition is somewhat tempered by the insertion of narrative features: a bust of Christ offers a Gospel book, and a bust of the Virgin an omophorion. This alludes to an episode in the bishop's life at the Council of Nicaea in 325, when Saint Nicholas had slapped the condemned Arius, inappropriately, in the presence of the emperor, whereupon he was stripped of his office and imprisoned, but restored to his rank when Christ and the Virgin returned his insignia to him.

A cycle of Saint Nicholas's life is depicted in sixteen scenes around the frame (not reproduced here), beginning with his birth and ending with his death and burial. This quite monumental type of icon with a cycle of the Saint's life became popular around the first half of the thirteenth century, the period to which this icon belongs, and is represented by several examples on Mount Sinai, all apparently painted there for various chapels—this one for the Saint Nicholas Chapel which was destroyed about half a century ago.

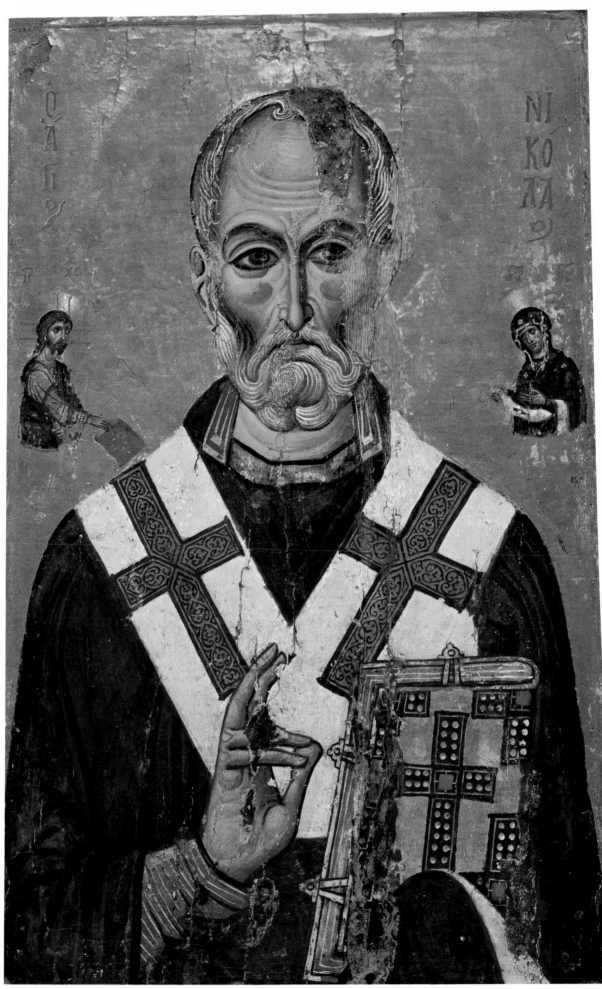

33

PLATE 34

SINAI, ICON WITH SAINT GEORGE

This monumental icon of Saint George was most likely commissioned for the chapel of that Saint, located atop one of the Monastery's wall towers. The youthful soldier, holding a lance and leaning on a shield, stands frontally, dressed in full armor (Plate 9) over a blue tunic, and wearing at the same time the ceremonial chlamys in red, with the inset square, the *tablion,* in blue (Plate 2).

Like Saint Nicholas (Plate 33), Saint George is surrounded by a narrative cycle of scenes from his life — in this case twenty — beginning with the Saint's distribution of his property to the poor in the upper left and ending with his burial at the lower right. These lively scenes are essentially based on the Saint's life as set down by Symeon Metaphrastes, to which, however, the scene of Saint George on horseback killing the dragon (just above the lower left corner) is apparently a later addition, and was soon to displace the standing saint as the main theme of the icons of Saint George.

Next to the Saint, in miniature scale, is the donor of the icon, the monk and priest John of the Iberians (that is, the Georgians). We have mentioned before (Plate 9) that there was a colony of Georgian monks living in Saint Catherine's Monastery, and it is hardly surprising that a Georgian should have donated an icon of Saint George, the national saint of his homeland. Still, the icon seems to have been made by a Greek painter working in the first half of the thirteenth century at Sinai, where at that time several such monumental icons with surrounding scenes were made for various chapels. The style is competent but slightly more rigid in the main figure, more decorative, especially in the gold pattern of the armor, and more summary and less refined in the scenes than one would expect from a Constantinopolitan work.

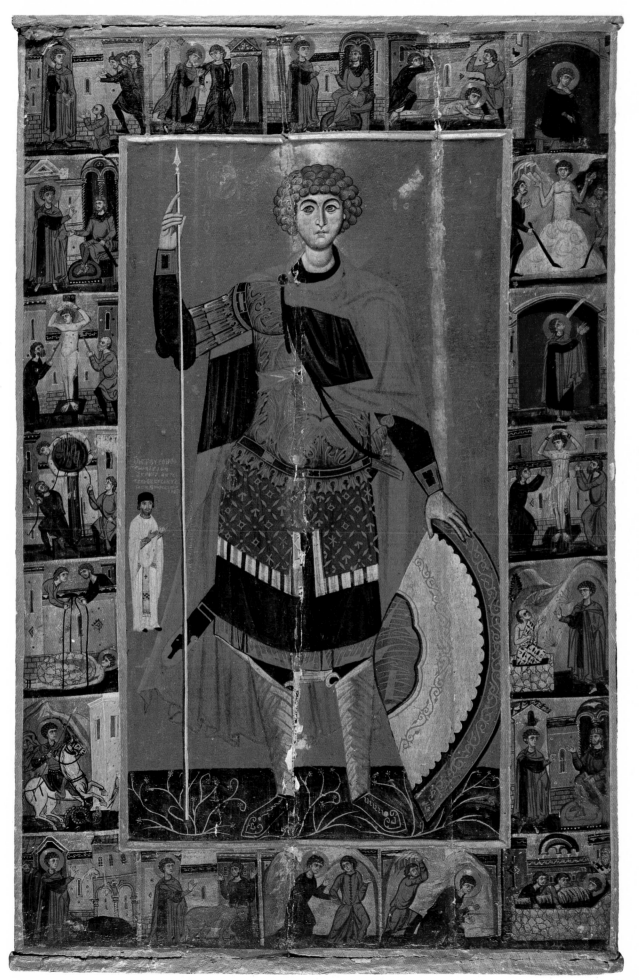

34

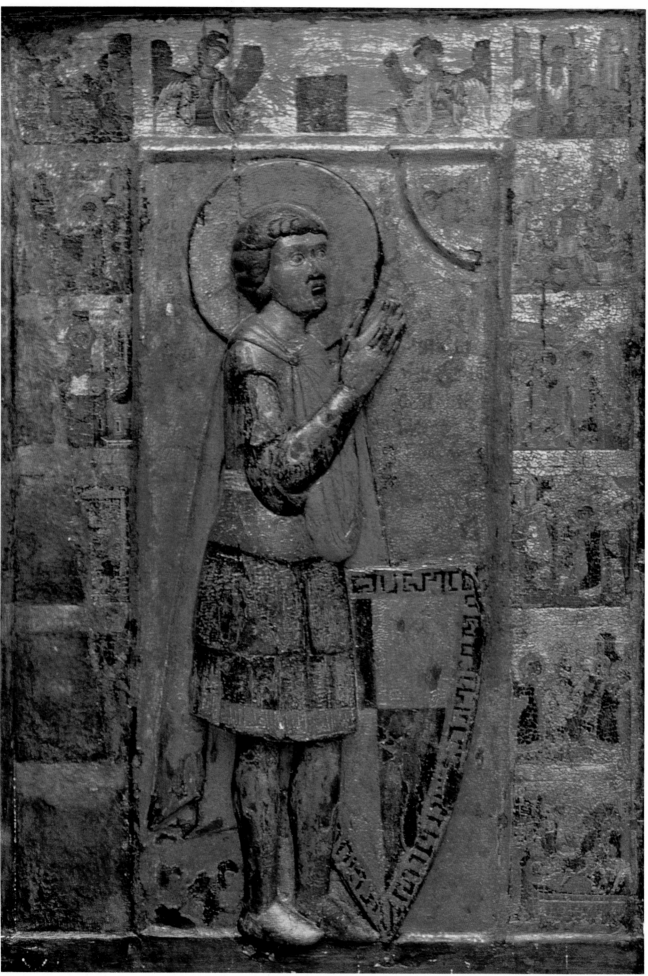

PLATE 35

ATHENS, WOODEN RELIEF ICON WITH SAINT GEORGE

Another icon of Saint George, likewise from the thirteenth century, and today in the Byzantine Museum in Athens, is in some respects totally different and in others closely related to the one at Sinai (Plate 34). Carved in wooden relief in rather heavy proportions, Saint George stands in profile praying to Christ in heaven, a pose rather unusual in Byzantine art, while his shield leans against him. Wood carving as such and details like the form of the shield reveal not only Western influence, but a style that actually suggests the work of a Western artist. On the other hand, the scenes of the life of Saint George which fill the lateral borders are iconographically very closely related to the Sinai icon, beginning with the same composition of Saint George's distribution of his goods and ending with his burial. In their delicate style, these scenes are even more purely Byzantine than those of the Sinai icon. Yet is should be noted that they do not run all around: the bottom strip has been omitted and the center of the top strip has been filled with two busts of angels instead of scenes; such an arrangement is again more in line with Italian Dugento art. The tiny painted figure of a female donor kneeling at the heels of Saint George, is, unfortunately, unidentifiable.

Such strong clashes of East and West, at times resulting from the cooperation of Latin and Greek artists, occurred in the thirteenth century in various places—in Constantinople, in the Balkan countries, on Cyprus, and in the Holy Land. The fact that a few more icons in wooden relief have been found in Macedonia may point to their origin in this region. On the other hand, the close relation of our panel's narrative cycle to the Sinai icon and the fact that one of the two identifiable female saints on its reverse side represents Saint Marina, may point to Sinai, in whose basilica Marina had a special chapel where many Marina icons are found.

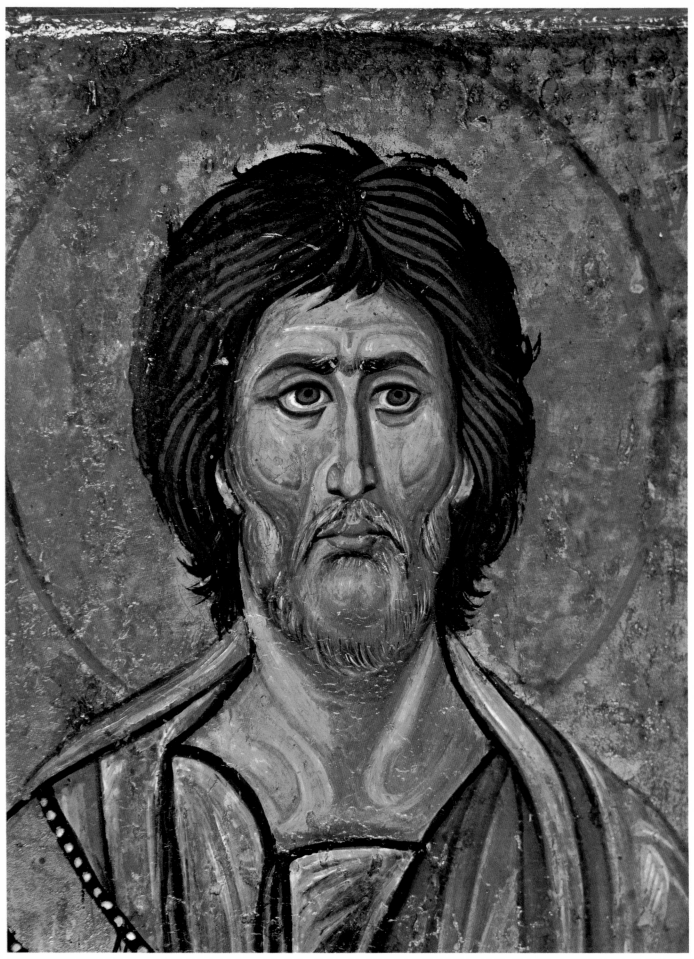

PLATE 36

SINAI, ICON WITH BUST OF MOSES (DETAIL)

The bust shows Moses blessing with his right hand and holding a scroll in his left with the beginning of the phrase in Greek: "And the Lord spoke to [Moses]." Moses is depicted with an emaciated face and dishevelled, dark hair, apparently inspired by the familiar head of Saint John the Baptist. Unusual in Byzantine art is the whitish shaggy beard: in Early Byzantine art Moses is usually depicted fully bearded and in Middle Byzantine art always youthful and beardless (Plate 18). On the other hand, this type of Moses with the shaggy beard occurs in quite a number of icons which were made in the Holy Land in a particular atelier at about the third quarter of the thirteenth century, as well as in the miniatures of a Bible in the Bibliothèque d'Arsenal in Paris which was made, surely by French miniaturists, for Saint Louis when the King visited Palestine from 1250 to 1254. We thus assume that this and all related icons were also made in the Holy Land, most likely at Acre by a French Crusader artist who may also have worked in the Monastery itself. This is only one of several styles of Crusader art produced by painters of different nationalities.

Compared with Byzantine painters, the Western artist worked with wider brushes by which a certain degree of spontaneity is achieved. The face of Moses is soulful and human and shows a high degree of naturalism, which increased in the Gothic period. This is the very element Byzantine art had traditionally avoided in order to stress the spiritual and the Divine in its icons.

112

PLATE 37

SINAI, ICON WITH SAINT PROCOPIUS (DETAIL)

Saint Procopius, a fourth-century Palestinian, is one of the four most prominent soldier saints, along with Theodore, George, and Demetrius (Plate 26, frame). Yet in this example, where Saint Procopius is depicted half-length on the left wing of a diptych, he is paired not with another soldier saint, but with a bust of the Virgin and Child. Both apparently are copies of very specific holy icons, the Virgin being derived from an icon supposedly painted by Saint Luke, now in the Monastery of Kykko on Cyprus, and Saint Procopius, as the epithet *Peribolites* ("of the holy precinct") suggests, being related·to a place where he was especially venerated, possibly the Church of Saint Procopius which was outside the walls of Jerusalem at Siloe.

The general impression is that the artist copied an icon which (like Saint Michael, Plate 14) was covered with gold, enamel, stones and pearls, as indicated by the gold-hatched mantle, the intricate armor, the pearl-studded crown of martyrdom held by angels, and the borders of the shield and nimbus.

Both wings have on their frames figures and busts all related to Sinai, including the Virgin in the Burning Bush, Saint Catherine, Saint John Climacus, and Saint Onouphrius. This speaks in favor of an origin in the Monastery itself. The style points to the second half of the thirteenth century, contemporary with and inspired by the works of the Sinai atelier that had produced the Saint George icon (Plate 34). Yet our painter is not Byzantine, but a Westerner, a Crusader artist, as is indicated by the almost harsh and more plastic style and by misunderstandings in iconography as well as in the Greek inscription. In our opinion he came from Venice, the city which had the strongest ties and the liveliest cultural exchange with the Holy Land.

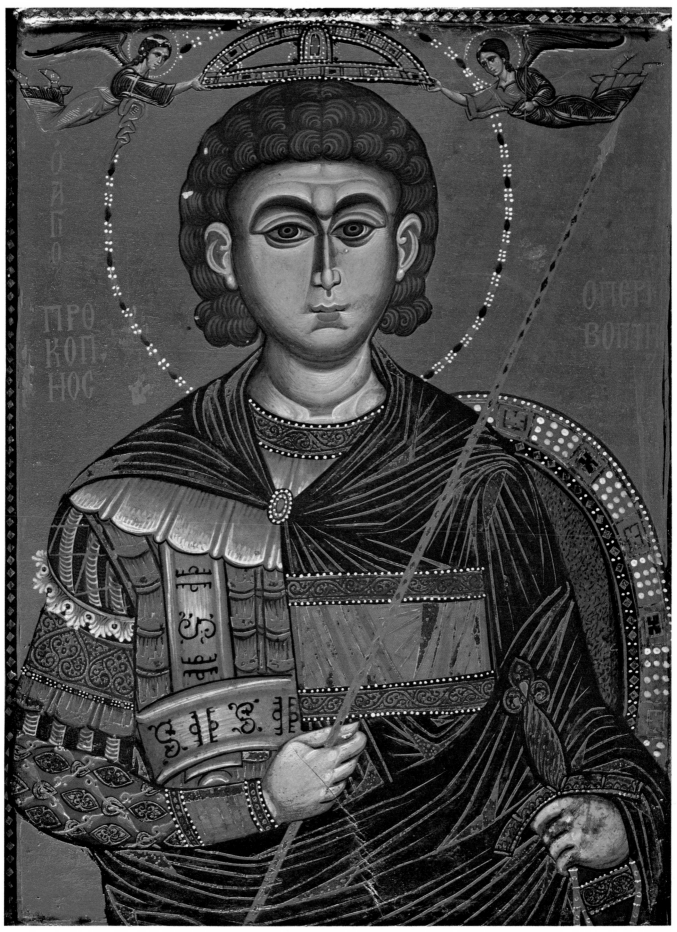

PLATE 38

SINAI, ICON WITH CRUCIFIXION

The obverse of this large bilateral icon shows the Crucifixion against a gold ground while the reverse has a densely crowded Harrowing of Hell against a blue ground. Although the general composition of the three-figure Crucifixion composition is that of the Byzantine feast picture, in many more specific respects the painter has asserted his Western origin. A marked emphasis on physical reality is displayed most vividly in the Herculean body of Christ, the corporeal rendering of John, and such realistic gestures as the Virgin touching the corner of her mouth with her thumb and Saint John touching his nose with his little finger—features which stand out in contrast to the aloof and slender figures of a pure Byzantine Crucifixion (Plate 26). The unrestrained weeping of the angels is another Western element, as is the use of only three nails, a motif which had just appeared for the first time in Northern Europe. Also Western is the punching not only of the nimbi (the metal nimbus of Christ is a later addition), but of the whole background with *rinceaux* and a diamond pattern; very conspicuous are the Latin inscriptions *Jesus Nazarenus Rex Iudeorum, Mater Domini,* and *Sanctus Johannes.* It is hardly possible to determine iconographically the origin of this painter. The new Christ type, created by Giunta Pisano, had spread into various parts of Italy, and the specific gestures of the Virgin and John occur even in a Crusader icon by a French painter and in a miniature in a Missal at Perugia, Umbria. Although it cannot be proven, we believe this Crucifixion, which belongs to the largest group among the many Crusader icons, to have been executed by a Venetian painter, as was the Saint Procopius icon (Plate 37).

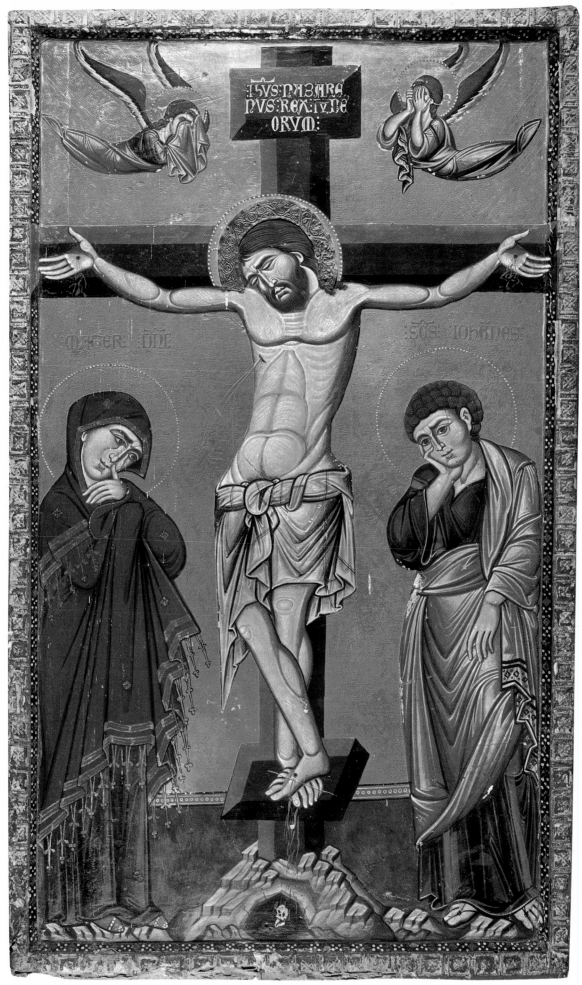

38

39

PLATE 39

SINAI, ICON WITH SAINT ANTIPAS

To this first-century martyr, mentioned in the *Apocalypse* (2:13) and venerated as the first Bishop of Pergamus, was dedicated a chapel (now the treasury) in the basilica of Saint Catherine's, and it is surely for this chapel that the icon of Saint Antipas was made. It is one of many Sinai icons whose background was over-painted in the eighteenth century with a then-fashionable sky blue. Restoration has only recently brought out the true colors, a blue *phelonian (chasuble)* and the old gold ground. The expressive plastically modeled face with an exaggerated emphasis on its muscles, the individually treated heavy strands of hair falling onto the forehead, the tufts of hair of the contracted eyebrows, and the wavy strands of the beard are all characteristics of the same Crusader atelier that produced the Crucifixion (Plate 38), and we propose also in this case a Venetian painter, who in all likelihood had worked for some years at Sinai, producing quite a large number of icons there.

PLATE 40

SINAI, ICON WITH THE DEATH OF THE VIRGIN

In depicting the Death of the Virgin (in Greek the *Koimesis*)—one of the greatest feasts of the Orthodox Church, celebrated on August 15—the Crusader artist revealed with particular clarity his artistic intentions, copying with great empathy a common Byzantine subject and at the same time showing his Western inclinations toward stronger realism and heightened emotionalism. Not only is the basic composition in every detail typically Byzantine—with Christ standing behind the bier, lifting up the soul of the Virgin to be carried to heaven by two angels, Saint Peter and Saint Paul leaning over the head and foot of the bier, and John, old and white-haired, bending over her body for a close look—but the addition of Bishops, here four, among them Dionysius the Areopagite, Hierotheos and Timotheos, as well as the episode of the Hebrew Jephonias, who tried to overturn the bier and was punished by an angel cutting off his hands, are also typical features in the Byzantine—though fairly late Byzantine—tradition. Yet Western features are the actions of the Bishop in profile who fans the incense in the lifted censer, the Bishop behind him who has just opened a book to read from it, the highly emotional gestures of sorrow of the Apostle at the left who turns around and covers his face with both hands, and in general the uninhibited expressions of grief in the faces of all the Apostles, some almost grimaces. The head of the Apostle at the right with crossed arms is very similar in style to that of Saint Antipas (Plate 39) even in such a detail as the tufts of his contracted eyebrows which are a kind of trademark of this atelier. Once more we believe a Venetian painter was at work here, an artist who most likely painted either in Acre or in the Monastery itself during the second half of the thirteenth century. The amazingly good condition of this icon, as is true of so many Sinai icons free of any restoration, shows a freshness rare in medieval panel painting.

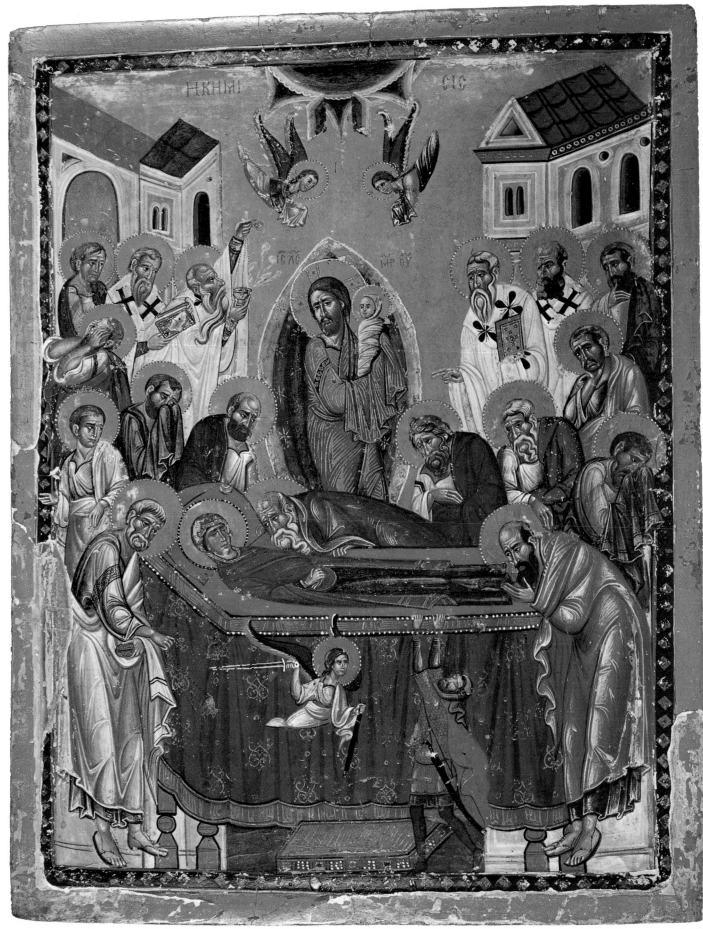

40

PLATE 41

Washington, D.C., Mosaic Icon with the Forty Martyrs of Sebaste

As did the carver of the tenth-century Berlin ivory (Plate 11), so does another Constantinopolitan artist, this time at the turn of the thirteenth to the fourteenth century, display his great skill in rendering the subject of the Forty Martyrs of Sebaste—this time in the most delicate mosaic technique. In the modeling of the naked bodies and variety of head types, classical models have played an essential role. But while the emphasis of the ivory icon, in accordance with the aims of the Macedonian Renaissance, was upon the agility and contortion of plastically formed bodies, in this mosaic, a product of the early Palaeologan Renaissance, the classical element consists rather of the imitation of a fleeting brush technique approaching impressionism in effect. At the same time, compositionally, the careful alignment of the martyrs in three distinct rows preserves an hieratic element with more dignified poses. The gestures of pain and suffering are not the same in the ivory icon, and while we suggested there the influence of a gigantomachy, the mosaic shows types which, among other sources, were influenced by those of the tormented damned in Last Judgment scenes. Another feature enhancing the martyrological character of the mosaic are the golden crowns of martyrdom suspended in the sky, neatly aligned in three rows as are the martyrs themselves, so that each can be related to its proper saint.

Astonishing is the minuteness of the tesserae, which decreased in size to the utmost during the Palaeologan period, and clearly imitated a miniature, to whose size the icon is comparable. The dating of the work must depend on the mosaics in the Kariye Djami in Constantinople, the key monument of the Palaeologan period, which is to be dated around 1310-1320. Our icon shows the same style in a slightly earlier, formative stage.

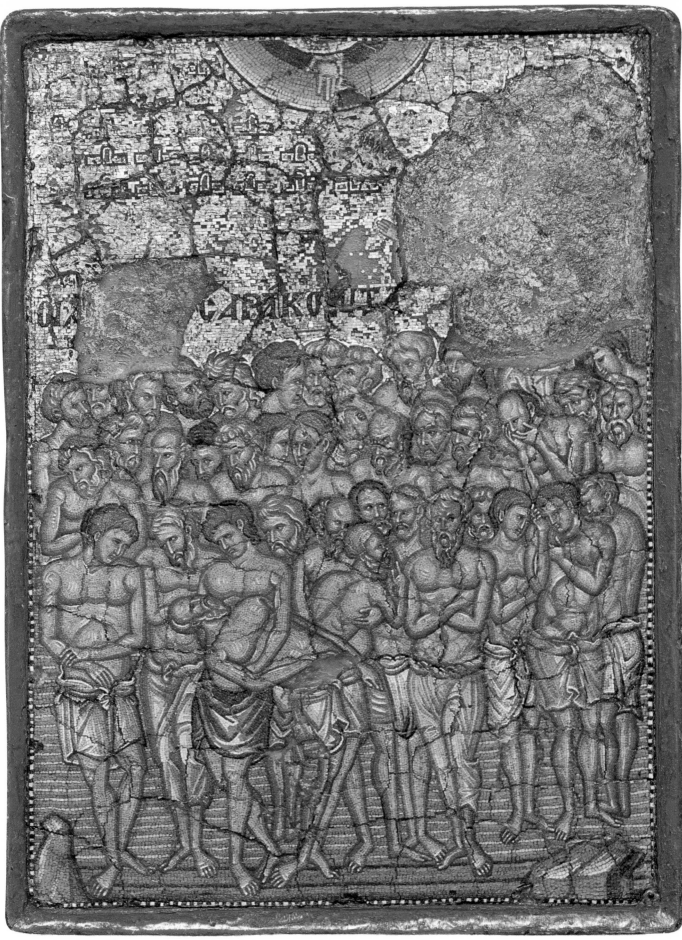

PLATE 42

Moscow, Icon with the Twelve Apostles

The *Synaxis* of the Twelve Apostles is celebrated on June 30 and in this icon they are assembled in two rows and identified by inscriptions, in the order of Acts I:13, save that Judas is replaced by Thaddaeus. Four are singled out to be seen in full view in the front; prominent among these is John, the second from the right, to whom Peter and Matthew turn with deference, talking and reading, while James at the left only turns his head slightly without participating in the conversation. Of the Apostles in the rear, some degree of prominence is given only to Andrew, off center, by showing more of his bust and his right hand and by stressing his dishevelled hair.

Especially in the four Apostles in the front row does the Early Palaeologan style from the early fourteenth century assert itself to the fullest advantage, conveying an impression of considerable corporeality, somewhat in conflict, however, with the rather slender figures that do not seem to fill the somewhat inflated garments. The sharp, flickering highlights, which almost give the appearance of bouncing off a metallic surface, also help to counterbalance the corporeal values. The subdued colors of the garments, rich in shades of brown, olive, and ochre, are enriched by *changeant* colors whereby in the same garment an olive color, for example, may change into a bluish tone. The highlights give an all-over effect of glittering silk.

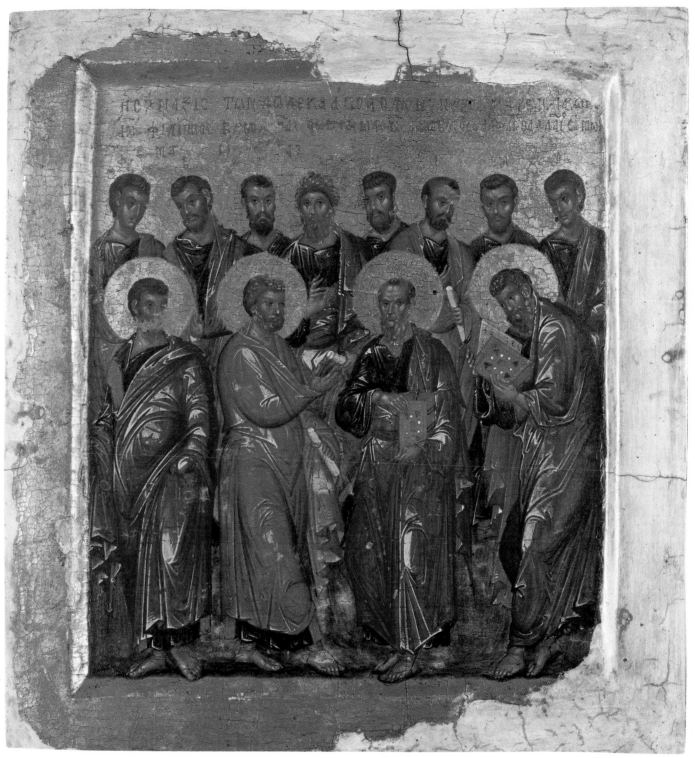

42

PLATE 43

SINAI, TRIPTYCH WING WITH SAINTS GEORGE, JOHN OF DAMASCUS, AND EPHRAIM SYRUS

In the top segment the panel depicts the bust of Saint George, fittingly matched on the other wing by that of Saint Theodore (Plates 2, 9, 26). Below in this wing stand the two monastic writers John of Damascus and Ephraim Syrus, balanced on the other wing by the two hermits Sabbas and Onouphrios. It follows the accepted order of rank that the soldier Saints are arranged above the monks, while at the same time the strong emphasis on the latter seems to indicate that we see here a work destined for a monastery. The central panel to which this triptych wing once belonged has been lost.

Compared with the previous Apostle icon, with which this wing is roughly contemporary, or perhaps slightly later (from the early fourteenth century), the figures here are even more elongated and rather frail—the long neck of Saint George, for example, exaggerates his slenderness. The folds of the garments, especially of the *mandyas,* the gown worn by John of Damascus, are multiplied, increasing their effect of metallic harshness. The elongation of the heads is emphasized by the tall hairdo of Saint George, the turban that John of Damascus wears from the twelfth century onward as an indication that he once was an official at the court of the caliph, and the cowl of Saint Ephraim. The fiery red of Saint George's chlamys stands in strong contrast to the otherwise subdued colors proper for monastic garments which have been treated here with a subtle juxtaposition of dark olive and light blue on the one hand and a red-brown and light violet on the other. The refinement which will lead to the mannerism of a later stylistic phase, points to Constantinople as this icon's place of origin.

43

PLATE 44

OHRID, ICON WITH THE ANNUNCIATION

On the reverse of a bilateral icon, whose obverse shows a bust of the Virgin with Child under an elaborate silver *oklad,* is the Annunciation. The panel is one of a pair with another bilateral icon depicting a bust of Christ and the Crucifixion. Both Christ and the Virgin have the epithet "Savior of Souls," which points to a monastery in Constantinople dedicated to the Virgin with that epithet. At the time of the Emperor Andronicos II (1282–1328), the abbot there was a certain Galaktion from Ohrid, and it was obviously he who sent home these two Constantinopolitan masterpieces.

A comparison with another Constantinopolitan masterpiece at Sinai, the Annunciation (Plate 27), makes clear the differences between the late Comnenian and Early Palaeologan art. Both Annunciations build on the contrast between movement and restraint. While in the earlier icon Gabriel recoils, here he advances vehemently in a wide stride and thrusts out his arm dramatically. The Virgin, instead of sitting in a frontal pose, is depicted recoiling and at the same time thrusting out her legs, giving the impression of a disjointed body under the heavy drapery. The lack of any relationship between body and bulging garments is even more apparent in the angel's figure. Spatial relationships play an intricate part in the dramatization of the scene, with the plinth supporting the Virgin's throne and footstool being pushed back beyond the massive marble plinth upon which the angel stands. Their diagonal alignment has been underlined by the hems of the angel's garments. Counterbalancing these lines with diagonals in the opposite direction is the fanciful baldachin, replacing the earlier house or church building with a coffered ceiling and a drapery overhanging two jutting beams. A color scheme dominated by subdued tones of grey blue, grey olive, and grey brown accented by the dark blue and dark purple of the Virgin's garments and the red of the cushion and drapery has a harmonizing effect on the dynamic design.

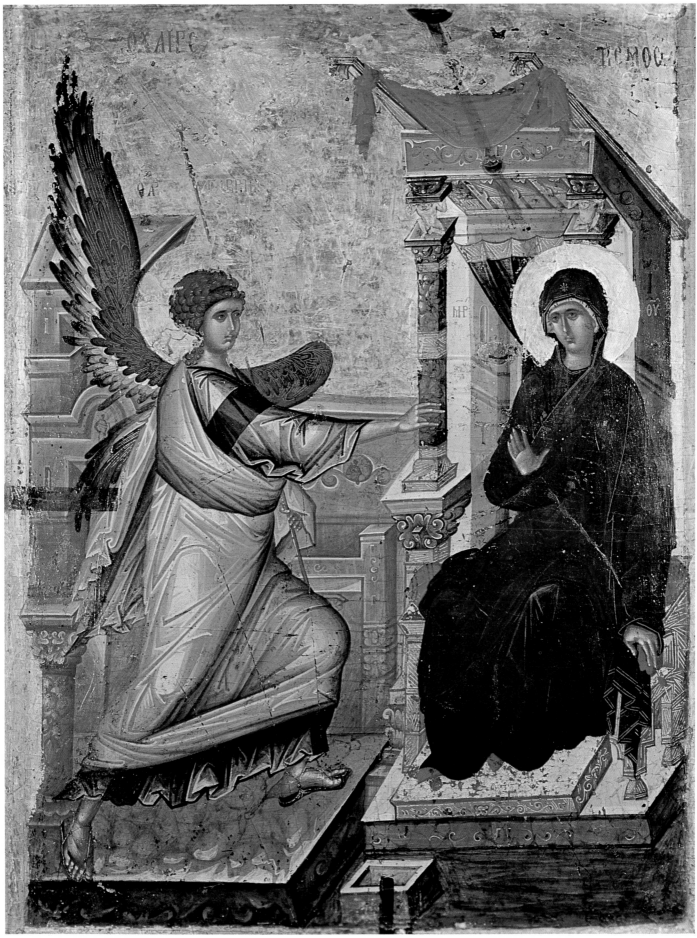

PLATE 45

London, Mosaic Icon with Annunciation

As Palaeologan art progressed it developed ever more frail human figures and drapery with brittle folds that have their own rhythm independent of the body underneath. This leads on the one hand to a sharper observation of human behavior and on the other to a dematerialization of the human body. Dating not long after the Ohrid icon (Plate 44), that is, about the middle of the fourteenth century, and surely also from Constantinople, this tiny mosaic icon of the Annunciation clearly demonstrates this trend. The slender standing Virgin shows a spontaneous reaction to the cautiously approaching angel. She controls her impulse to turn away, but she seems slightly to recoil. Apparently she has risen rather suddenly from the throne on which she was seated, spinning. As in the previous icon, this one also plays upon the contrast between movement and restraint, but in the case of the angel's garments, instead of bulging, the artist gives them crumpled, brittle folds which jut out at the end of the mantle in defiance of gravity.

Yet the main difference is not so much one of date as of scale. The greatest refinement ever achieved in mosaic occurred in a group of miniature icons of the fourteenth century, which show great artistic sensibility in relating the frailty of the body to its miniature size.

To achieve the impression of material preciousness, the artist used not only tesserae of marble, but also semiprecious stones such as lapis lazuli, gold, and silver, and he applied decorative elements clearly inspired by enamel technique, such as the patterns of the floor, the foot cushion, the angel's nimbus, and the inscription tablets (Plate 16). Compared with the brushwork of the Ohrid icon where subdued colors of many shades are employed, the mosaic technique lends itself to an emphasis on stronger and more contrasting colors.

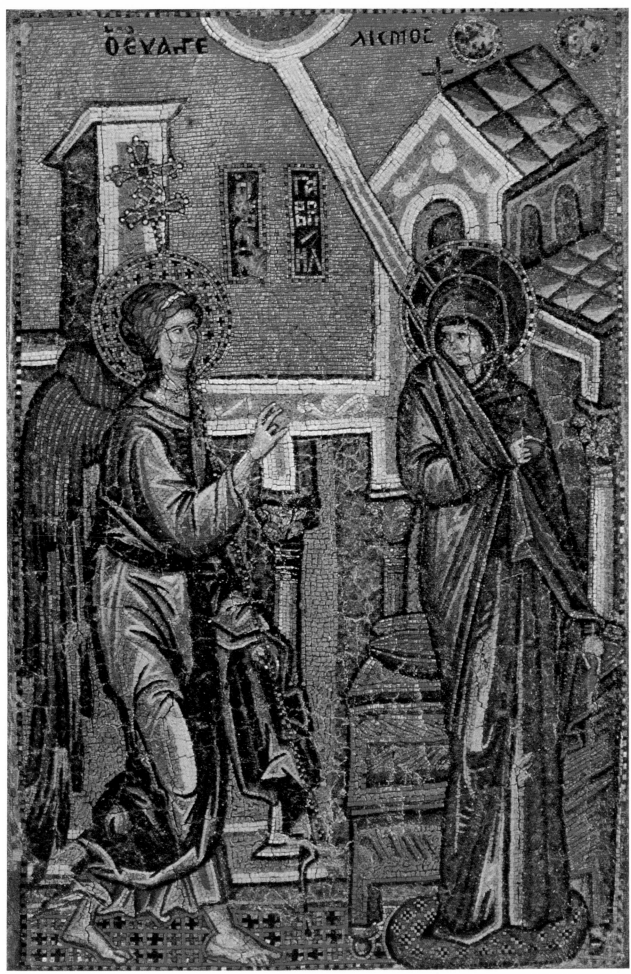

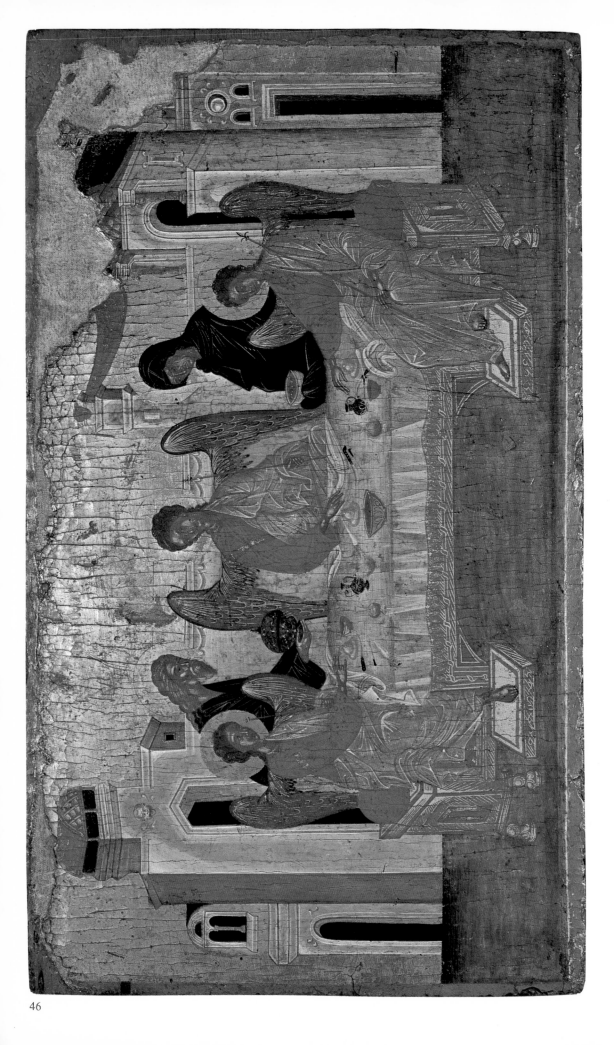

PLATE 46

ATHENS, ICON WITH THE HOSPITALITY OF ABRAHAM

At the root of the difficulty experienced by Byzantine art in rendering pictorially the Holy Trinity lies the firm belief that God the Father should not be represented in human form. Yet artists did find two solutions to this problem: God could either be depicted in the manifestation of Christ as the Ancient of Days (Daniel 7:7 and 22), together with figures of Christ and the Dove of the Holy Spirit, or the Trinity could be presented symbolically as the Three Angels who visited Abraham in the grove of Mamre (Gen. 18:1–15). This interpretation is found in miniatures in twelfth-century Bible manuscripts, the so-called Octateuchs, already inscribed: "Holy Trinity," as well as in icons of the Late Byzantine period.

One of the very finest and earliest is this Trinity icon, for which an unusual horizontal format was chosen which allowed the painter to make a rich display of the broad, laden table, set against an architectural backdrop which lacks depth and rather reminds one of a theatrical set made up of cubic props. In a rather loose composition, the angels sit widely separated from each other so as to provide space between them for Abraham and Sarah, who are serving. This creates a rhythmic order whereby the angels, dressed in light red, alternate with the dark-clad servants, and it is apparently for this purely artistic reason that—contradicting the text of the Bible—Sarah also is introduced as a servant.

In this icon from the end of the fourteenth century the dematerializing process of Palaeologan art has been continued. The angels have not only become even more slender and their bodies buried under garments with accumulated crumpled folds, but the light red adds to their ethereal appearance, contrasting sharply with Abraham's and Sarah's dark garments. In the soft, curving lines of the angels there is a lyrical, almost mystical quality which a few decades later would lead to the most famous Angel Trinity icon, by the beatified Russian icon painter Rublev.

PLATE 47

SOFIA, ICON WITH THE VIRGIN AND SAINT JOHN

This masterpiece is one of the very rare cases for which we know not only its precise date but also the historical circumstances of its creation. It was sent home to the Monastery of Saint John at Poganovo as a gift by the Byzantine Empress Helen, wife of Manuel II, granddaughter of the Bulgarian Czar Ivan Alexander, to commemorate the death of her father, the despot Constantine Dejanov, who was killed in 1395 in the battle against the Turks; this is believed to be the date of the icon.

It is a stately, bilateral icon, whose obverse depicts the "Mother of God of Refuge" as she is inscribed, and Saint John the Evangelist—in this form a rather unique association of the two. Obviously the types are derived from a Crucifixion, and the Virgin especially, raising her *paenula* to her face in a gesture of mourning, follows such a model very closely. While it is unusual in Byzantine Crucifixions, the depiction of John white-bearded is common in the *Synaxis* of the Apostles (Plate 42). Yet the type does occur in a pre-iconoclastic Crucifixion icon at Mount Sinai, and thus it seems quite possible that the Sofia icon harks back to an early Crucifixion.

In support of such a view is the reverse of the icon, which represents Christ in heaven appearing in a theophany to two Prophets, presumably Ezekiel and Daniel, although their identification is not assured. What is certain, however, is that this composition copied the fifth-century apse mosaic of Hosios David in Thessalonike, and from this fact scholars have deduced that the Sofia icon was executed in that city. Yet Constantinople, where in all likelihood it was commissioned by the Empress, must also be considered a possible, and even likely, place of origin.

Compared with the preceding Palaeologan icons, the figures have preserved a higher degree of corporeality which may well be explained by their adjustment to the comparatively monumental scale of the icon. The Virgin and John turn their bowed heads toward each other in grief as well as affection, although the human element is somewhat tempered by the abstract, deep olive-colored shadows in the faces. The concentration of color in a deep and lighter blue on the garments and even John's beard, is as striking as it is harmonious.

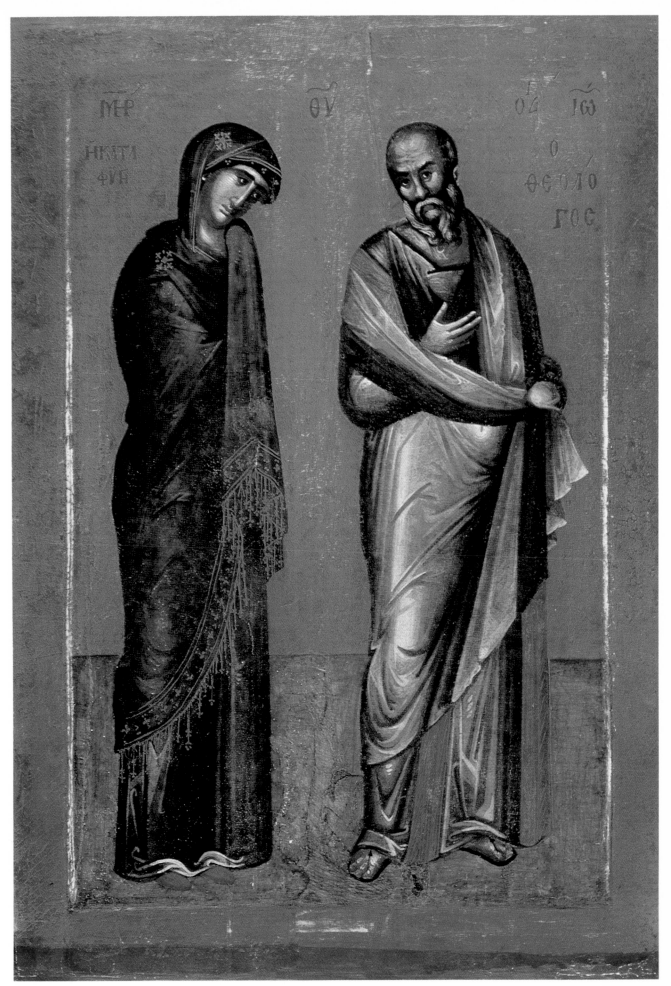

PLATE 48

SINAI, ICON WITH JOHN THE BAPTIST

The half-length figure of John the Baptist turning to the left with a gesture of prayer was quite certainly one of a set of three forming a *Deësis* (Figure VII), the other two depicting the Virgin, turned to the right with a similar gesture, and a central, frontal Christ.

Nowhere is extreme asceticism and a sense of pain so concentrated as in the figure of Saint John the Baptist, the tragic Prophet, and no other phase of Byzantine painting brings out these qualities so strongly as Late Palaeologan art, in which frailty and dematerialization reach a peak. The emaciated face, in which olive dominates over brown, the dishevelled hair with its restless outline, the fleeting highlights on the garments, the steel blue *melote* of sheepskin, and the olive-colored mantle, contribute essentially to the impression of an almost phantom-like appearance.

At the end of the fourteenth century this style, so close to impressionism, celebrated its greatest triumph in the frescoes of Theophanes the Greek, who had painted for a considerable time on Byzantine soil before he went to Russia to paint at Novgorod the well-known monochrome figures over which highlights scurry in eccentric, flickering strokes. The style of this contemporary icon well explains the milieu from which Theophanes grew.

Yet the impressionistic manner as such, though carried to extremes in this phase of Palaeologan art, was by no means an invention of the time but was rooted in Early Christian painting, to which Palaeologan art harked back just as much as it did to that of the Macedonian Renaissance. The icon of Saint John the Baptist in Kiev (Plate 7) anticipates this one in sentiment, fleeting brush technique, and coloration.

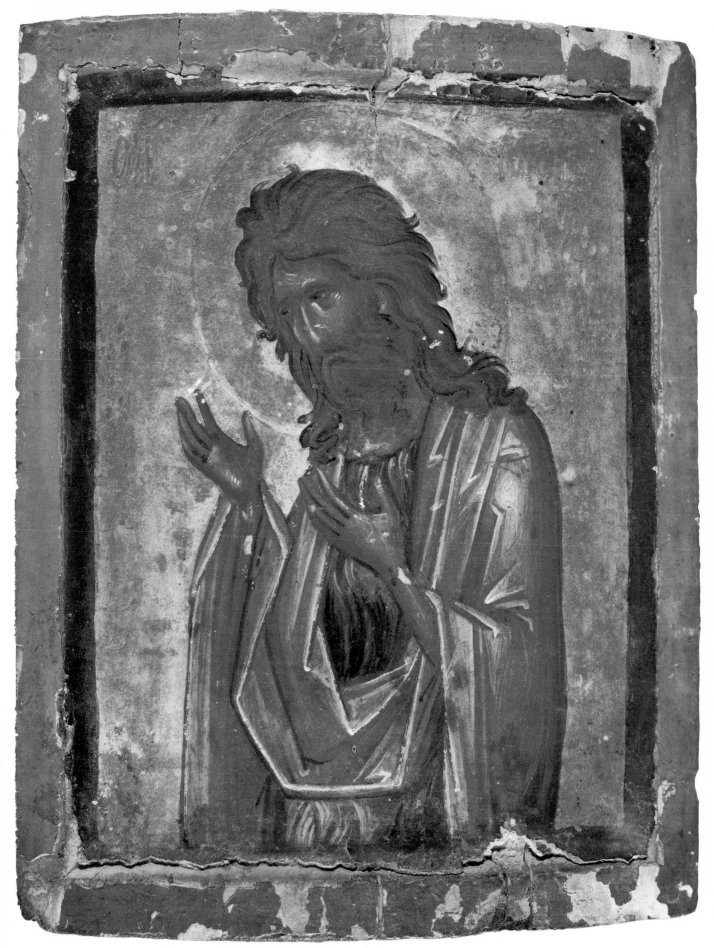